IMAGE AND IDOL:

MEDIEVAL SCULPTURE

Published by the
order of the Tate
Trustees 2001 by
Tate Publishing a
division of Tate
Enterprises Ltd,
Millbank, London
SW1P 4RG
© Tate 2001
ISBN 1854374001
Published to accom-
pany the exhibition
at Tate Britain:
19 September 2001
– 3 March 2002
A catalogue record
for this book is avail-
able from the British
Library
Designed by UNA
(London) designers
Printed in Great
Britain by Balding
and Mansell
Cover: Recumbent
figure of Jesse late
15th century [12]
Photo: Tate
Photography

CONTENTS

FOREWORD The story of British art did not begin with the arrival of Hans Holbein in England in 1526, or with the native school of painting which was to flower over the following hundred or so years. Yet many past surveys of the course of art in Britain have started their narrative in just such terms, neglecting the many preceding centuries' diverse traditions of craftsmanship across the visual arts. Moreover, the real revolution in British art between *c.*1540 and *c.*1650 lay not so much in the undeniably important progression of native painting, its patronage and its profile, but, as this exhibition and catalogue reveal, in the parallel and systematic damage and destruction across the land of innumerable works of medieval religious art. These post-Reformation, anti-Catholic assaults on religious imagery were to remove a significant portion of Britain's heritage forever.

Some art of great quality and interest survived, however, either intact or only partly damaged, and the works selected for this exhibition are a poignant indication both of the violence that reigned for that most destructive period and of what else, too, was made and might in other circumstances have remained. Though the selection does cover several media and styles it certainly does not aim to provide a survey of sculpture of the period. It is instead the outcome of a collaboration between the art historian Phillip Lindley and the artist Richard Deacon, whose diverse interests in the appearance, meanings, styles and materials of sculpture from the twelfth to the early-sixteenth centuries fused together and focused upon the twenty-three works they brought together for the exhibition. I am extremely grateful to them for accepting our invitation to work on an enterprise of this kind and then to do so in such fruitful partnership.

Throughout they have been supported and guided too by Tate Britain curator Clarrie Wallis, assisted by Lizzie Carey-Thomas, and I would like to pay tribute to their achievement in realising with apparent ease a particularly complex project. Thanks too are due to Martin Myrone and Sheena Wagstaff of Tate Britain for their important contribution to the early stages of the project, and also to Andrew Graham-Dixon and Simon

Jenkins for their encouragement once it was underway. For generously supporting the cost of restoring the Sir Thomas Andrew monument from Charwelton we are very grateful to The Daniel Katz Gallery, and for financial support for the exhibition itself we are pleased to acknowledge the generosity of The Henry Moore Foundation and the Mercers Company. Above all we are indebted to the lenders to the exhibition. Without their enthusiasm and support – and, it must be said, their spirit of adventure – such an undertaking could not have been attempted.

 This is the first Tate exhibition to present art of this kind and date, and it coincides with the opening of our new displays of the re-housed permanent collection that lies at Tate Britain's heart. I believe the exhibition provides the collection displays with an invigorating and thought-provoking context – one, it may be hoped, of many to come.

Stephen Deuchar
Director
Tate Britain

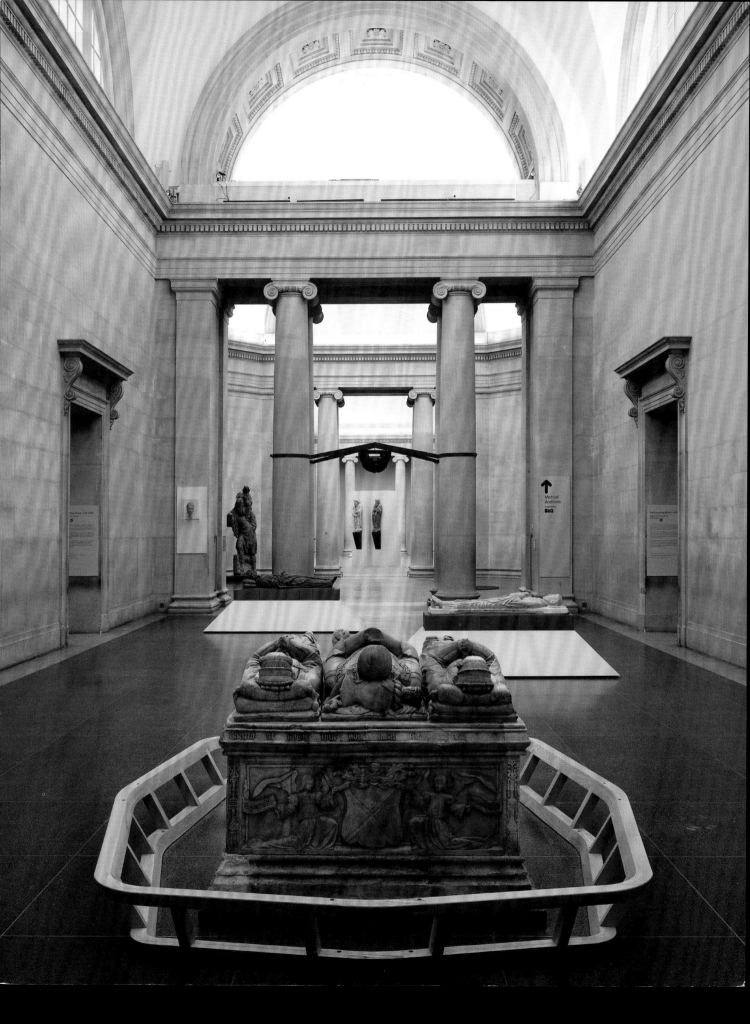

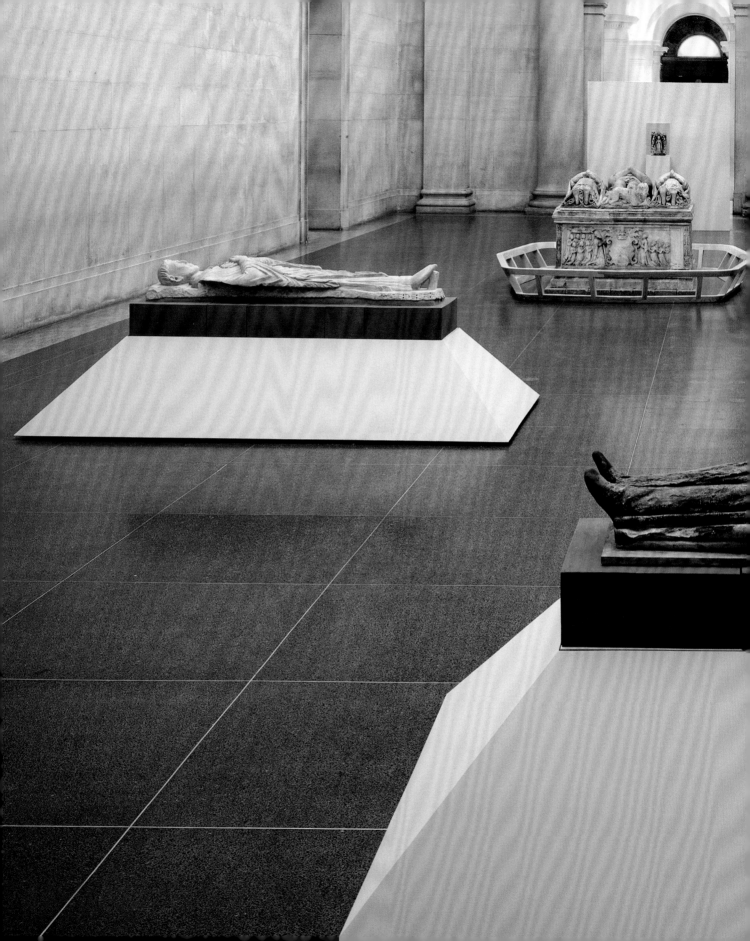

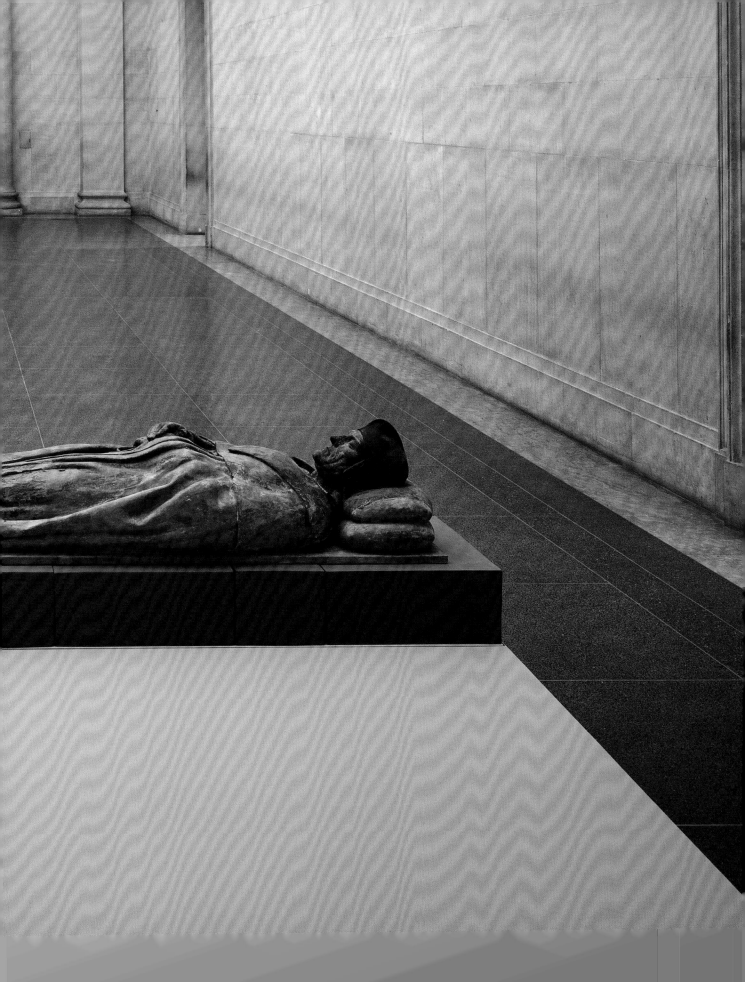

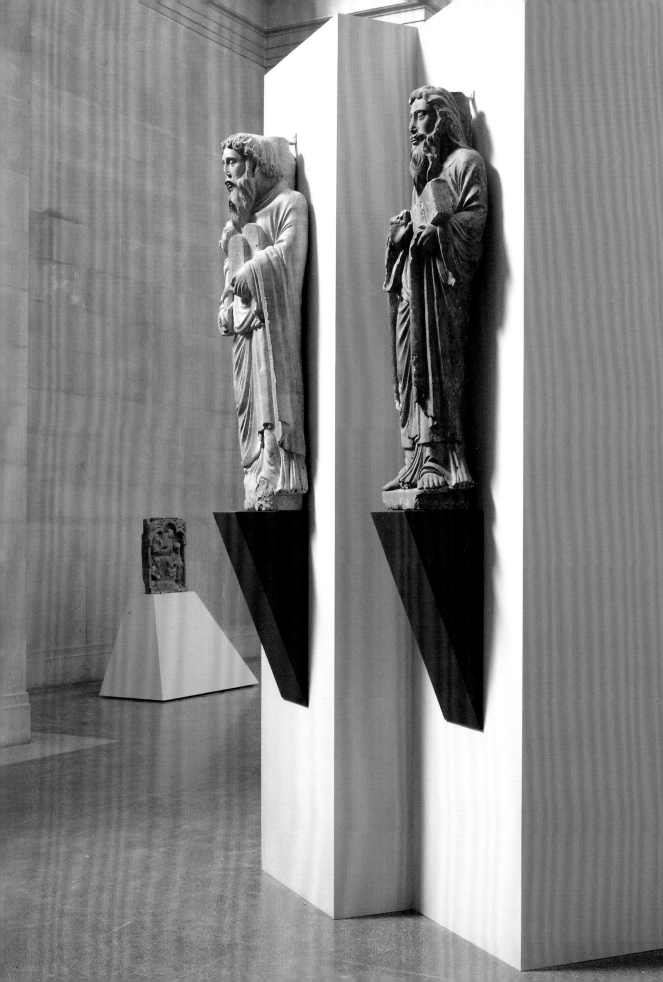

NEW BASES FOR OLD SCULPTURE
RICHARD DEACON

'AND IF THOU WILT MAKE ME AN ALTAR OF STONE, THOU SHALT NOT BUILD IT OUT OF HEWN STONE: FOR IF THOU LIFT UP THY TOOL UPON IT, THOU HAS POLLUTED IT.'
Exodus 20:25

From the destruction of the Golden Calf, through the Reformation to the Taliban's recent destruction of the ancient Buddhas at Bamiyan or the tipping over of statues of Lenin after the fall of communism, there is a long history of hitting out at three-dimensional images. One has to ask why.

In his account of the excavations at Ur between 1922 and 1934, *Ur of the Chaldees*,[1] Sir Leonard Wooley has some interesting things to say about the way in which artifacts are treated. One of the early discoveries on a brick pavement, exposed while clearing the Ziggurat, was a fallen statue of Entemna, king of Lagash (a northern Babylonian city) and sometime overlord of Ur. The head of the statue was missing, deliberately broken off in antiquity, but the stump was polished, as if by being continually slapped or touched by passing hands. Such touch can be talismanic. A cast of Rodin's great sculpture *The Age of Bronze* used to be installed, along with the rest of the Victoria and Albert Museum's collection of nineteenth-century French sculpture, in the Bethnal Green Museum of Childhood. Against the rich black patina of the surface two areas of bright yellow metal stood out. These were his penis and the big toe of his advanced right foot, both gleamingly polished by the surreptitious caresses of countless passing schoolchildren.

'Nothing helps an excavator like violent destruction', wrote Wooley,[2] delighted at discovering a layer of charred and burnt material in the foundation mounds of the buildings being excavated. His inference was that this layer presented an undisturbed rubble upon which later structures had been erected. So it turned out. In the centre of one of the excavated courtyards were shards of inscribed black stone. When pieced together these were found to belong to a shattered war memorial to the Babylonian king and Sumerian overlord, Hamurabi. Wooley's detective work in the dust led him not only to fire but also to its cause. Sparked by an uprising in the city against the overlords – as evidenced in the smashed memorial – Babylonian troops

above:
Scholarly copy of writing on bricks of Amar-Sin, BC 675-655
The British Museum
left:
foreground, left, Moses *c.*1200 [1]
foreground, right, An Apostle (?)
*c.*1200 [2]

trashed the place. Prague spring followed by Soviet invasion.

J.E. Taylor, then British Consul at Basra, first excavated Ur
in 1854. Wooley was indignant about his methods but enchanted
by his discoveries. 'Hidden in the brickwork at the top stage of
the tower he found, at each angle of it, cylinders of baked clay
giving the history of the building.'[3] The inscriptions describe the
restoration and completion of the tower by Nabonidus in about
BCE 550. There is a recognizable civic pride in these inscriptions
and an admirable discretion in hiding them. For the archaeol-
ogist, though, there is something else. 'These inscriptions not
only gave us the first information obtained about the Ziggurat
itself, but identified the site, called by the Arabs al Mughair, the
Mound of Pitch, as Ur "of the Chaldees", the biblical home of
Abraham.'[4]

In the last phase of the excavation, Wooley described finding
within the (school) house occupied by Princess Bel-Shalti-Namar
(the sister of Bel-Shazzar, whose feast became such a subject in
art), a small group of objects that have no temporal relationship
to each other. It was only on looking more closely at the clay
tablet found beside them that he realized that what he was look-
ing at was a label, and that this building had been a museum or
there must at least have been a collection shelf.

Thus within an account of the excavation of perhaps the
oldest city in the world, there is evidence of collection, conser-
vation, destruction and desecration. It is an extraordinarily
familiar history.

Sometime in 1990 Mark Francis and Lynne Cooke, who were
curating the 1991 Carnegie International, approached me and
asked if I'd be interested in 'doing something', based on the
collection of the Carnegie Museum of Art. They approached me
as an artist who had taken part in the previous International and
whose work was in the collection, as well as someone who had
recently held a solo show in the Museum. I therefore seemed
well placed to produce an interface between the display of the
Museum's permanent collection and the upcoming display of
the Carnegie International. After several trips and explorations
of the Museum store, I arrived at a selection of objects that I was
interested in working with. The objects fell into three groups.
The first were all made of wood: a child's chair by Gerrit
Rietveld *c.*1920, a sculpture, *Structure*, 1945, by Isamu Noguchi,
and a Yoruba Housepost by Owo-eye of Ilesha *c.*1930-50. They
were all early to mid twentieth-century objects and all used the
same basic material, but each was made very differently. The
second group were all nineteenth century and were materially
diverse: a silver berry spoon from the Gorham Company, n.d.;
a gilt and lacquer centre table attributed to Louis Le Prince-
Ringuet and Marcotte *c.*1855–60; a bronze cast of Jean-Baptiste
Carpeaux' *Genie de la Danse*, 1869. The final group was a single
work, David Smith's *Cubi XXIV*, 1964. For each of the three
groups I constructed a display stand which I called an 'island',
of aluminium tread-plate for the first, laminated and carved
wood for the second and vinyl flooring for the third. I titled
these 'islands' as if they were independent works. The title of the
exhibition, 'Facts Not Opinions', is the legend carved over the

Buddha statue, AD *c.*4-5
Bamiyan, near Kabul; destroyed 2001

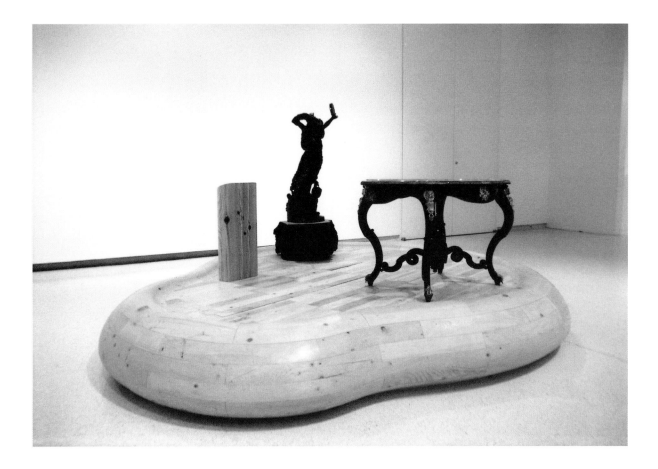

Richard Deacon
'Facts Not Opinions',
Carnegie Museum, 1990

entrance to the Kirkaldy Materials Testing Laboratory in South London; as I wrote at the time, 'This confident assertion has always impressed me. In many ways it aphoristically describes a function that the things I have called "islands" might have. Material, labour, skill, productivity, belief, history, discourse and desire are amongst the components of that function.'

My experience of this interaction with the Carnegie's collection was perhaps behind Tate Britain's invitation to co-curate, with Phillip Lindley, an exhibition of medieval sculpture, scheduled to co-incide with the opening of the newly remodelled Tate building on Millbank. Certainly, in the display I have devised, the use of materials has something in common with the display at the Carnegie.

Another point of reference has been my memory of the reinstallation of the Egyptian galleries at The British Museum at the end of the 1970s. The galleries were kept open during the re-installation, and many of the objects were temporarily propped up. The great arm of Rameses II for example, was supported by a pile of sandbags and a very hefty timber banker. Both this kind of propping up and the equipment associated with moving the stone artifacts, spoke eloquently of weight and mass, an eloquence that is somehow absent in a more permanent display. The revivification of materiality also returned the objects to a more active, or at least more present, existence in the world. One of the things I have been conscious of trying to do in the installation at Tate Britain is to reintroduce, through the use of particular supports, this aspect of the physical existence of the objects on show, to emphasise that they are solid and have weight. I hope that a grasp of materiality might lead the viewer to empathise in some way with the object, or at least come to the recognition that these objects belong to a world which has connections with our own. Perhaps an anecdote will convey what I mean here. In the early 1970s my mother was very ill and, although a student in London, I made quite frequent visits to my parents' house. As an active twenty-year-old I was restless and always looking for jobs to do, partially I suppose so that I could feel useful. Anyway, for whatever reason, sometime in 1970 or 1971 I was digging in the vegetable patch, turning it over and removing the shards of white convulvulus root that turned up, squashing leatherjackets and wireworms. While bending down to inspect a newly turned sod my eye was caught by a piece of stone. On picking it up I found that it was a worked flint, the point broken off, but nevertheless clearly shaped. The feeling of contact, that somebody else had dropped this some 3000 years before, was extraordinary, like a jolt of electricity.

The display opens with a freestanding wall that supports the Virgin and Child from Winchester Cathedral. It will be the first thing you see when you enter Tate Britain from Millbank; it is an outstanding and beautiful image to encounter. The sculpture is at the beginning in part because images of the Virgin Mary were ubiquitous before the Reformation. The first iconoclastic attacks included Marian shrines, so its position in the display reflects the centrality of this imagery. There is also a sense in which the

top:
Removing a granite sculptured head of King Amenhotep III from the main stairs of The British Museum
above:
Upper part of a sculpture of King Rameses II awaiting installation in the Egyptian Sculpture gallery at The British Museum

body and life of Christ is figured in the display, with the Virgin and Child at one end, and the crucifixion genealogy at the other. Two iconic saints – George and Christopher – are in the middle. Coming into the display around the wall holding the Virgin, one sees the alabaster panel of the Assumption and the Charwelton tomb, two objects connected by material but disconnected by ideology. Although the supporting angels around the Virgin and the angels supporting the coat of arms have something in common, it is what they hold up that has changed. The alabaster tomb of Sir Thomas Andrew and his two wives is both the only complete tomb and the most recent object in the display. The tomb remained complete partly because it was made after the first waves of the Reformation, and therefore not subject to the same kind of destruction as those made earlier, and partly because it comes from a very small parish church, under the protection of a powerful family. The base sections are made from reclaimed material – there are remains of inscriptions on inside faces. It is quite decorative. The wooden rail that surrounds it is a protective barrier but is also sculptural, paralleling the role of aluminium or terracotta in other parts of the display. The guardrail radiates from around the tomb like a splash from a thrown stone. A similar rail is used around the giant figure of St Christopher from Norton Priory. St Christopher is carved from a sliver of red sandstone. In order to represent water the sculptor has had to show it tipped up behind the Saint's feet. The sculpture is therefore both a low relief and a three-dimensional piece at the same time. Look at the way the fish bend around St Christophers carved leg. The sculpture was included in the display because it has enormous presence as a physical object, as well as because it is a familiar image. At the centre of the display are two of our most familiar saints, St Christopher and St George. The St George from Eton stands 3m high on a black steel column that rises out of a black ellipse like Excalibur from the lake. It is also a somewhat idolatrous presentation – if one thinks of medieval representations of antiquity or of idolatry, the image is often atop a freestanding column.[5] The sword behind St George's back is presented in an interesting way: the illusion is complete from the front, but from the back you can see that the rest of the sword isn't there; the sculpture was intended to been seen frontally and from below. It is displayed so that the architecture of the Duveen galleries becomes a frame for the object. Both St George and St Christopher are in the central octagon of the Duveen galleries. A boss from York Minster is mounted on an arched truss braced, like Samson in the Temple, between the four columns at the end of the south Duveen. I wanted to include this timber boss, the only non-figurative work in the display, to show that the use of imagery in the pre-Reformation period was far more widespread than that used in later buildings. Very few sculptors would put their works on a ceiling now, but in a Gothic Church imagery covered many of the surfaces. I wanted an item in the display that showed this inverted relationship to gravity: a heavy object hung upside down.

There are six recumbent figures in the display. Each one is on

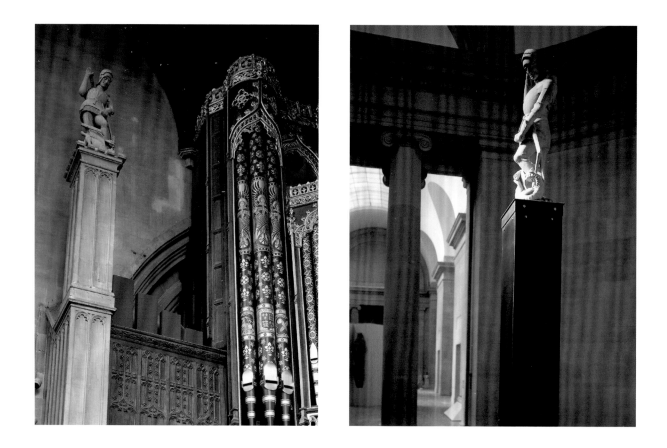

above left:
Statue of St George c.1510
Eton College Ante-Chapel
and right:
Statue of St George c.1510 [14]

a plinth which has a kind of skirt around it. Between the plinth and the figure is a mattress of a different material – aluminium, terracotta, wood. The two knights from Furness Abbey are in full armour, and appear to be standing up although they are lying horizontally. Its clear that these knights are really walking – they're stepping out – so really they're standing up but they happen to be lying down on the ground. The three armoured figures in the exhibition are all displayed on aluminium matt-resses. The use of the bright metal is a material reference to their armour, although the texture is like woven cloth. The reflective brightness also refers to the figures looking towards their resurrection. The third aluminium mattress is under the double effigy from Careby in Lincolnshire. This representation of two recumbent figures makes almost no concessions to horizontality: you could stand it up and it would function perfectly well, whereas lying down it looks strange. The figures seem to be in bed, but are fully dressed. The bedcover makes them appear bodiless: the block is plain, almost austere. The bottom half has no decoration or foot supports; it is just a simple fluted surface, slightly bowed. Both figures are carved out of a single block rather than assembled from two different pieces. It's an extra-ordinary solution to a two-figure problem. Two of the other mattresses are made of terracotta bricks, one under the effigy of Dr Yonge (itself made of glazed ceramic) by Pietro Torrigiano and the other under Thomas de Redying. These two effigies have interesting formal connections, although both artists arrived independently at a similar formulation, one in a rural context the other in a sophisticated metropolitan environment. The Thomas de Redying effigy is a kind of vernacular oddity. The way in which the figure is represented is a departure from tradition; there is no context for it, no history – the sculptor simply decided to do it that way. The figure is clearly dead, and strangely enough because he is dead he is closer to us. Armoured figures lying on the ground waiting for resurrection seem to have very little to do with us, whereas a tomb figure of a dead body is comprehen-sible. And look at the elegant way his closed eyes are carved. In contrast, the Torrigiano effigy of Dr Yonge is a piece of sophisticated sculpture by an urbane and cosmopolitan artist. The head and the hands (and perhaps the hat) are life cast; the rest of the figure, in its rich but austere gown, is modelled. At one level this is expeditious, relying on the faithfullness of casting to reproduce physiognomy. Sophistication lies in uniting these elements into an expressive whole. The terracotta blocks supporting both figures are a rich absorbent orange-red, con-trasting with the bright reflectivity of the aluminium under the armoured knights and echoing the material of the Torrigiano sculpture. A head from Winchester is mounted on a wall near the north end of the south Duveen. This small head of a man in a skull cap is bursting with energy; its location close to the effigies of Dr Yonge and Thomas de Redying allows a sense of the portrait of an actual individual, in life as against death, into the display.

Four figures from York, two from the Minster and two from St Mary's Abbey Yorkshire Museum, stand together, each at a height of 1.6m. The unit on which they stand is stepped on one

side like a portal and angled on the other like a façade. These
sculptures were selected for the exhibition both because of
their quality, and because these standing figures are obviously
architectural fragments. The design of the central column was
an attempt to find a way to show them as part of a larger piece
of architecture. The St Mary's figures are displayed on the
stepped side of the column; this is a shorthand way of suggesting
an interior context for these figures. With massive upper body
weight, Moses thrusts himself forward like a pit bull, carrying
the tablets of law. In contrast the apostle, carrying a wonderful
book like a rock, is more distant, less weighted. The heavily
weathered figures on the angled faces of the column from York
Minster have been conserved in a quite straightforward way:
they sit on massive stone blocks with a column of stainless steel
at their backs. I am interested in the way this conservation has
affected their qualities as objects, and how this mediates between
what I have been doing and the objects. The fact that the
St Mary's figures seem to be complete does not mean they have
not been interfered with; it is just that the interference is not so
obvious, so what is hidden in them is revealed by what is ex-
posed in this display.

A torso of the Risen Christ from Winchester is on a slightly
oversized table beside an alabaster retable panel from
Northampton of the Resurrection. In this panel Christ steps
over a prone knight who has some resonance with the two
Furness Abbey knights. The table has a backboard, as if the
tablecloth has been pulled up, a reference to the iconography of
St Veronica's veil – the handkerchief given to Christ to mop his
face on the Via Dolorosa and which took a miraculous image.
The torso is pinned to the backboard of the table so that the
image in the alabaster makes evident what is missing in the torso.
Opposite the torso is a fragment of a lavabo from Much Wenlock
Priory. This fragment was selected partly to indicate some of the
likely sculptural subjects of the pre-Reformation period; imagery
was present in all aspects of daily life, particularly in the monas-
tery. This piece of Romanesque carving is a small part of a much
larger whole, forming one panel of an elaborate eight-sided
lavabo. The lavabo was a functional object – a wash basin – that
would have been in daily use by the monks in the Abbey.

The sensational Jesse figure from Abergavenny is at the far
end of the north Duveen gallery. Chosen because of its particular
quality and size, there would have been a whole tree sprouting
from the loins of this figure, with the entire genealogy of Christ
displayed in its branches. Carved from a single enormous piece
of oak with a particular strong and confident sensitivity to line
and scale, it sits on a mattress made of richly grained Douglas fir.

Near to this wooden figure is a polychromed stone figure
from the Tree of Jesse in St Cuthbert's Church, Wells, as well as
the fragments of a wooden crucifix from South Cerney, now in
the British Museum. This delicate carving is the earliest object in
the show and a rare survivor. The distance apart at which the
head and the foot are displayed allows the missing body to be
inferred. The poignancy of the loss of the body is emblematic of
the display as a whole. Very stringent environmental conditions

1
Sir Charles Leonard Wooley, *Ur of the Chaldees*, London 1929.
2
Wooley, 1929, p.121.
3
Wooley, 1929, p.89.
4
Wooley, 1929, p.90.
5
Thanks to Phillip Lindley for reminding me of this.

had to be met for this work; it is displayed inside a climate-controlled box, a very daunting object. The severity of the box in relationship to its contents is interesting: the box evokes in some sense the fragility of the image, and in a way it displays the museum inside the museum. Facing the box and also in a climate controlled box of its own is a figure from the Tree of Jesse at St Cuthbert's Church in Wells. A matching head and body that have quite substantial remaining polychromy on them were chosen from the smashed remains of a Tree of Jesse. This colouring is absent from most of the other figures displayed. The Jesse figure at St Cuthbert's did not survive intact: it was virtually erased from the wall, an erasure so intense that it made the figure evident by its absence, like Rauschenberg rubbing out de Kooning's drawing. There is a connection between the representation of Christ in the broken crucifix and the genealogy displayed by the Jesse motif. Using the new entrance to Tate Britain this will be the constellation that the visitor comes across. Opposite the Jesse figure is a small statuette of a female saint (Helen?) from Forde Abbey. This small, half life-size figure, is very delicate and pretty. She has something in common stylistically with the Winchester Madonna, although the former is a cruder representation. She is shown atop a conical, black steel stand which spreads out like a skirt around her, and which acts as a counterpoint to the elevated figure of the armoured St George. The rudimentary carving at the back of each of these two images of saints evidences practical decision-making and clarity about the difference between the image and its object. What you see is what you get. On the other hand, the figures of Sir Thomas Andrew and his two wives have been elaborately painted and polychromed even in the parts hidden from view. Upon dismantling the tomb chest, this colour, pristine in all its richness, was revealed to those of us lucky enough to be there. There is something in this about work under a Protestant dispensation and about satisfying the demands of an all-seeing God with whom you are in direct contact.

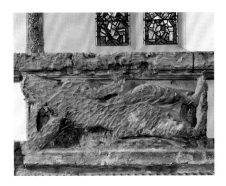

Defaced Effigy of Jesse
St Cuthbert's Church,
Wells, Somerset

previous pages:
Vault boss early 15th century [5]
right and below:
Statue of St Christopher carrying
the infant Christ *c.*1375-1400 [8]

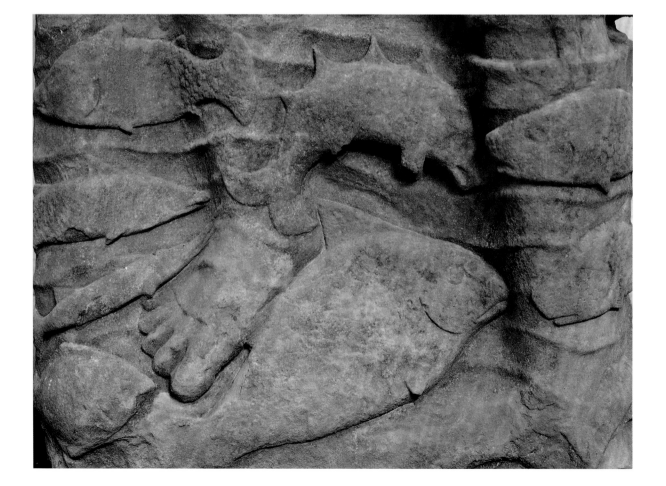

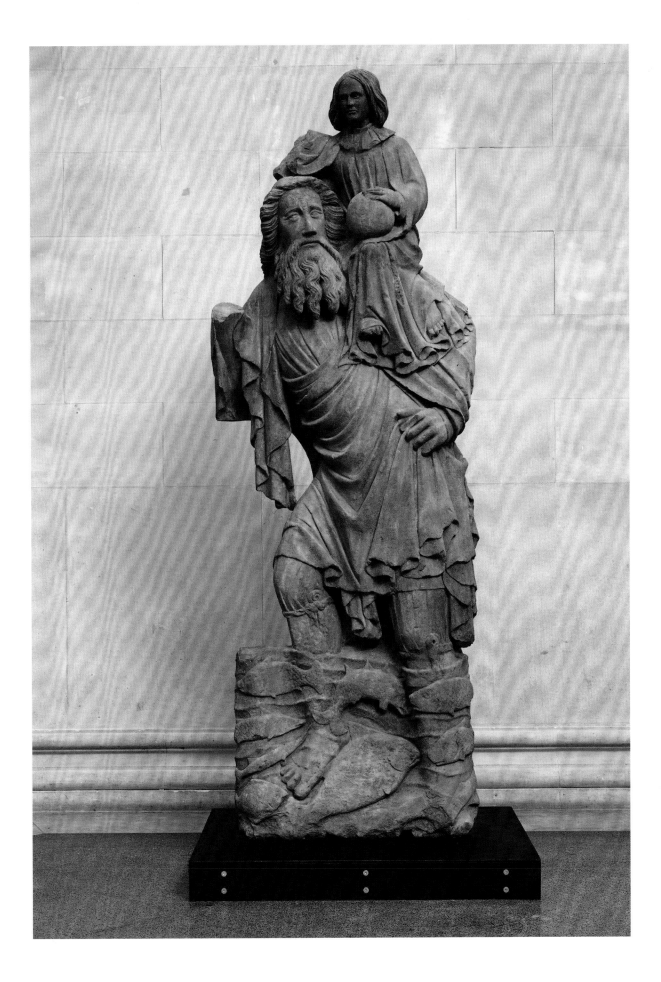

Statue of St George *c.*1510 [14]

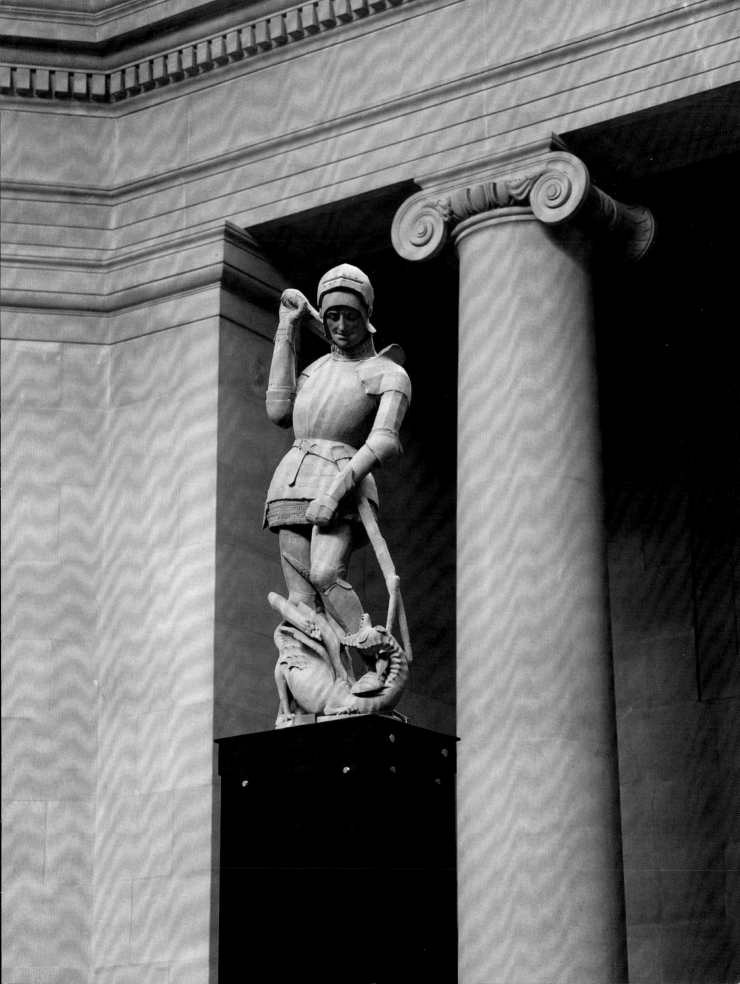

Girolamo da Treviso (1497-1544)
A Protestant Allegory *c.*1542-4
The Royal Collection

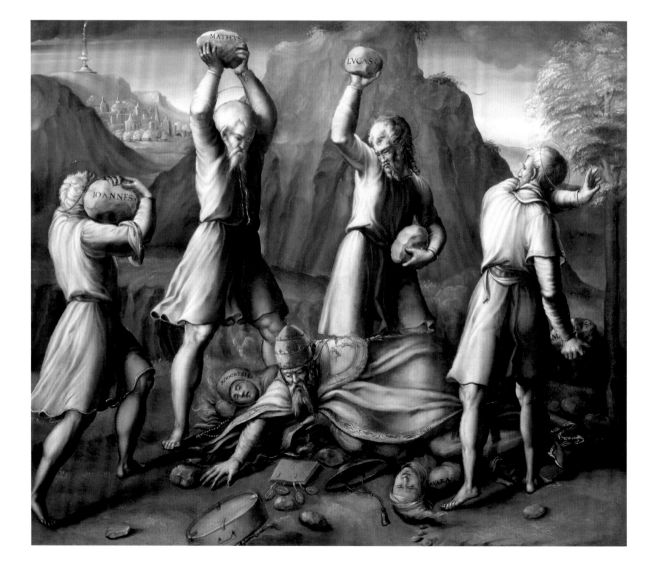

I INTRODUCTION

THE greatest revolution in the history of the arts in England and Wales occurred in the middle of the sixteenth century. Until the Reformation, England and Wales shared a common religion with the rest of Western Europe, a religion which had the Pope at its head. Under Henry VIII, however, the king became supreme head of the national church; monasteries were dissolved, pilgrimage ended and a first onslaught on religious images was launched with the ostentatious destruction of internationally celebrated pilgrimage sculptures.[1] During Edward VI's short reign (1547-53) the attack on medieval imagery widened, and nearly the entire heritage of medieval figure sculpture was obliterated.

Virulent hostility to religious imagery in any form resurfaced under Queen Elizabeth I and during the Civil War (1642-51) it resulted in new a devastating attacks. By the end of the 1640s, no more than a tiny fraction of medieval religious imagery remained. Only tomb monuments, which were protected by powerful, families and deep social conservatism, survived in substantial numbers. Indeed, under Elizabeth and the early Stuarts, massive tomb monuments, sometimes adorned with symbolic and allegorical imagery, constituted the bulk of all sculptural commissions. Yet neither they, nor an increased taste for secular sculpture, could compensate for the loss of commissions for religious imagery.

The clash of conflicting certainties in the sixteenth century resulted in the near total obliteration of the religious sculpture of the Middle Ages and limited what was permissible in British art for centuries. As an immediate consequence,

1.
Before the Reformation, a painter named Edward Frere evinced Reformist sympathies by the texts he added to his paintings: see J. Foxe, *Actes and Monuments of these latter and perillous dayes ...*, London 1563, pp.490-1. Christ is depicted on Foxe's title page, and it is important to recall that Protestants of his type were not against *all* religious imagery: see M. Aston and E. Ingram, 'The Iconography of the *Acts and Monuments*', in D. Loades (ed.), *John Foxe and the English Reformation*, Aldershot 1997, p.75.

2.
I hope that the late Francis Haskell, who criticised the transporting of works of art to temporary exhibitions (see his *The Ephemeral Museum: Old Master Paintings and the Rise of the Art Exhibition*, Yale 2000) would have approved of this.

3.
Scotland was, throughout, a separate nation, although in 1547 it did look for a moment as if dynastic union would create a single realm of Great Britain: see D. MacCulloch, *Tudor Church Militant: Edward VI and the Protestant Reformation*, Harmondsworth 1999, p.126.

the focus in the later sixteenth century was on portraiture and a restricted range of painting genres. The break with Rome ended the influx of Florentine Renaissance sculptors. A retreat from the medieval practice of painting sculpture and a widespread and enduring hostility to all religious figure sculpture were longer-term effects. The redefinition of the sacred and the triumph of the Biblical word over devotional sculpture, as well as permanently changed landscapes, cityscapes and church and house interiors, were all legacies of the Reformation. Modern scholars increasingly stress the continuities of traditional practice and religion into the later sixteenth century and well into the seventeenth. What must have struck contemporaries was how much had changed.

This exhibition of a contested heritage of sculptures is intended to provide some insight into what was destroyed, what survived and why. Constructed by artist Richard Deacon, it has rich thematic, chronological and geographical diversity, and includes several tomb monuments especially conserved for the exhibition.[2] The sculptures shown here were produced in England and Wales between the twelfth and sixteenth centuries, but not necessarily by British sculptors.[3] Images by artists from the Low Countries and from Florence are included; German and French sculptors also worked in England during this period.

Specialist medieval figure sculptors (although they did not necessarily work *solely* on figure sculpture) existed from the Romanesque period; later documentation reveals workshops specialising in particular materials or genres such as tomb sculpture. Scholars have not been able to connect many sculptors' names to surviving works, but that is largely an accident of survival. So many sculptures have been destroyed, and references to them in the archives are scanty. The latter is partly because sculptors in medieval Britain were generally craftsmen with a

relatively lowly status. This had changed somewhat by the end of the Middle Ages when wealthy heads of workshops which mass-produced imagery might hold important civic offices; visiting continental stars, such as Pietro Torrigiano in the sixteenth century, certainly enjoyed a different level of prestige. He, and the other Italians at the court of King Henry VIII, introduced new materials and new sculptural genres into sixteenth-century England. A genre which was to have profound consequences for the future was the portrait bust; these sculptors also introduced other types of secular imagery and classical subjects. Torrigiano appears to have imported a new sense of the sculptor as a creative artist rather than a craftsman.[4]

Whatever the status of medieval sculptors in Britain, the objects they produced often possessed an enormous potency and significance. Defining them as 'art' in our contemporary sense is anachronistic for a variety of reasons. Most obviously, although obtaining an appropriate level of quality was an explicit concern for most patrons, aesthetic discrimination can hardly ever have been the dominant factor in the viewer's response.[5] The vast majority of all medieval sculpture possessed explicitly religious functions. Today we usually see only the grey, ruined remains of sculptural programmes.[6] But late-medieval figure sculpture often had naturalistically painted and textured surfaces; popular devotional sculptures – which seem frequently to have been carved from wood – might be dressed with precious cloaks and clothes and wear silver or gold shoes and jewellery given to them by hopeful supplicants and devotees.[7] Thus, in 1528, Joan Tackle of Honiton left a silver cross to one image and her best blue girdle to a statue of the Virgin in the parish church.[8] One of Queen Elizabeth's Homilies vituperatively ridiculed these 'great puppets, wondrously decked and adorned; garlands and coronets be set on their heads ... their dead and

4.
P. Lindley, *From Gothic to Renaissance: Essays on Sculpture in England*, Stamford 1995.
5.
See M. Camille, *The Gothic Idol: Ideology and Image-Making in Medieval Art*, Cambridge 1989, pp.338ff.
6.
An exhibition at The Henry Moore Institute in Leeds in 2002, curated by Stacy Boldrick, David Park and Paul Williamson, will concentrate on sculptural polychromy.
7.
J.C. Cox, *Churchwardens' Accounts*, London 1913, p.148, for a 1488 inventory of the image of the Virgin in the chapel of the Bridge at Derby, decked with jewelled cloths, beads, girdles etc. A. Vallance, *Greater English Church Screens*, London 1947, pp.7-8, for a list dating from 1524 (relating to a Rood image).
8.
R. Whiting, 'Abominable Idols: Images and Image-breaking under Henry VIII', in *Journal of Ecclesiastical History*, vol. 33, no. 1, 1982, pp.30-47.
9.
M. Aston, 'Gold and Images', in *Faith and Fire: Popular and Unpopular Religion, 1350-1600*, London 1993, p.226.
10.
J. Phillips, *The Reformation of Images: Destruction of Art in England, 1535-1660*, Berkeley 1973, p.75. See also M. Aston's invaluable *England's Iconoclasts, I, Laws Against Images*, Oxford 1988, p.173.
11.
For revisionist views of the demise of Catholicism in England, see for e.g. C. Haigh (ed.), *The English Reformation Revised*, Cambridge 1987. The quotations above are from p.7.
12.
For salutary correctives, see N. Tyacke, 'Introduction: Re-thinking the "English Reformation"', in Tyacke (ed.) *England's Long Reformation 1500-1800*, London 1998, pp.1-32; D. MacCulloch, 'New Spotlights on the English Reformation', in *Journal of Ecclesiastical History*, vol. 45, 1994, pp.317-24.

stiff bodies are clothed with garments stiff with gold. You would believe that the images of our men Saints were some princes of Persia ... and the idols of our women Saints were nice and well-trimmed harlots.'[9]

One of these 'whores' seems to have been cross-dressing. When, in 1537, in an extremely early attack on a cult image, Bishop Hugh Latimer had the statue of Our Lady of Worcester stripped of her precious garments and jewels, she was apparently found to be an image of a bishop.[10]

Revisionist historians of the Tudor Reformation have insisted that the 'traditional religion' of the Middle Ages was healthy in the 1530s, that there was no deep religious discontent, that the Reformation was 'piecemeal ... to be explained by the chances of day-to-day politics', and that there was 'no cataclysmic Reformation to be explained by mass enthusiasm or a revolutionary party'.[11] It is true that seeing late-medieval religion wholly from the viewpoint of the victorious Protestants is to caricature it and to present the Reformation as the inexorable progress of God's will.[12] On the other hand, the claim that England and Wales had 'an ersatz Reformation, an anaemic substitute for the real thing' may sharply overstate the counter-thesis – at least so far as the destruction of medieval sculpture was concerned. The devastating effect on Catholic piety of the ridiculing and official destruction of hundreds of thousands of medieval images should not be played down.

It would be absurd to try to comprehend medieval imagery solely in terms of its subsequent destruction. The second part of this essay focuses on the selected sculptures in the display, situating them in terms of developing genres, stylistic and iconographic innovation, polychromy, function and patronage among other concerns. Although much of the sculpture exhibited here is of outstanding stylistic quality, this is not a compilation of 'greatest

hits' that emphasises stylistic 'progress' at the expense of all other qualities.[13] The very notion is a post-medieval one, and is a damagingly crude and inappropriate tool to apply to some of the spectacular heterogeneity and idiosyncratic fecundity of these sculptures. I hope that I have ensured that the images selected here – some of which are unknown even to specialists – provide a dramatic evocation of that richness and stimulate further research.

13.
Medieval works of art were often explicitly based on earlier examples.

Acknowledgements
I would like to thank
Dr M. Aston, Dr S.J. Gunn,
Dr Miriam Gill, Mr Philip
Lankester, Dr Sophie Ooster-
wijk, Dr D. Postles, Professor
Cinzia Sicca and Professor
Greg Walker for many helpful
suggestions and corrections.
They are not responsible for the
views expressed in this essay nor
for any errors it may contain.

Effigies of knights in full armour
*c.*1250-75
Furness Abbey, Lancashire

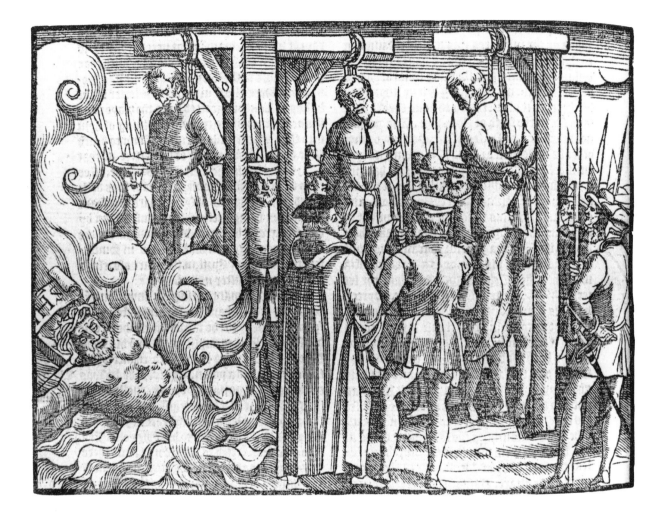

Woodcut of 'Three Dovercourt Martyrs
Hanged for Taking Down the Rood of
Dovercourt'
from John Foxe's *Actes and Monuments
of these latter and perillous dayes …*, 1563
Cambridge University Library

II IMAGE AND IDOL

ONE moonlit winter's night early in 1532, with a hard frost falling, four determined young men walked the ten miles from Dedham to Dovercourt in Essex, where the parish church housed a famous Rood or crucifix. It was widely believed that the celebrated Rood possessed such miraculous power that it protected the church, which could therefore be left unlocked. Taking advantage of this, the men slipped into the open building, took down the crucifix, carried it to a nearby field and set it alight with the very candles which had been offered before it by supplicants. Within six months, three of the men had been caught, judged and hanged in chains. Only one escaped to tell the story, which was printed by the great Protestant apologist, John Foxe, in 1563.[1]

Six years later, on 24 February 1538, John Hilsey, Bishop of Rochester, delivered an emotive sermon at St Paul's Cross in London as a prelude to the stage-managed destruction of another miracle-working crucifix. The Cistercian priory of Boxley in Kent had been dissolved on 29 January and during the dismantling of the church's imagery, the crucifix known as the Rood of Grace – a celebrated object of veneration and pilgrimage – was discovered to be a mechanical puppet containing 'certain engines and old wire, with old rotten sticks in the back of the same, that did cause the eyes of the same to move and stare in the head thereof like unto a living thing; and also the nether lip … to move as though it should speak'.[2] In a rousing sermon, Bishop Hilsey denounced the fraudulent deceptions of images, demonstrating and ridi-

1.
Foxe, 1563, pp.495-6. The three men were accused of stealing the garments and shoes of the Rood and were hanged for felony. See J.C. Cox and J.H. Round, 'Ecclesiastical History', in *Victoria County History of Essex*, vol. II, London 1907, p.21.

2.
I have used the modernised English in G.H. Cook, *Letters to Cromwell and Others on the Suppression of the Monasteries*, London 1965, p.144. For the Rood of Grace see W. Page (ed.), *Victoria County History of Kent*, vol. II, London 1926, p.74; Vallance, 1947, pp.9-12. See also the invaluable essay by M. Aston, 'Iconoclasm in England: Official and Clandestine', in *Faith and Fire: Popular and Un-popular Religion, 1350-1660*, London 1993, pp.267-70, and her *England's Iconoclasts*, 1988, to both of which my deep debts will be evident. The Boxley image appears to have been made of paper and cloth from the legs upwards, the arms and legs being of timber; the most similar (partly) surviving images to this in England are the Queen Elizabeth of York and Henry VII funeral effigies from Westminster Abbey.

3.
Vallance, 1947, p.10, points out that Boxley Abbey had already been styled 'Abbatia S. Crucis de Graciis' by 1412, so this may have been a fourteenth-century rood. For the details, see J. Gairdner, preface to *Letters and Papers of Henry VIII*, vol. 13, part. 1 (1538), pp.viii-x.

4.
Foxe, 1563, pp.571-2; Aston, 1993, p.276, 303-4. Ironically, Latimer was himself, of course, burnt as a heretic for his beliefs under Queen Mary. W.D. Hamilton (ed.), *A Chronicle of England During the Reigns of the Tudors, from AD 1485 to 1559, by Charles Wriothesley, Windsor Herald*, London 1875, vol. I, pp.79-81. See also *Letters and Papers of Henry VIII*, vol. 13, part 1 (1538), pp.xv-xviii, 694 and 863.

5.
Aston, 1993, p.275.

6.
M. Aston, 'Lollards and Images', in *Lollards and Reformers: Images and Literacy in Late Medieval Religion*, London 1984, pp.135-92 and 170. For an attempt to answer the heretical objection to pilgrimage to 'our Lady of Falsyngham (Walsingham) … of Foulpette (Woolpit) and Thomme of Cankerbury (Canterbury)', see also pp.172 and 186, n.176.

culing the crucifix's movements before breaking its mechanisms and throwing it to the indignant crowd who reportedly tore it apart and burnt the remains.[3]

On 22 May of the same year, a large wooden statue of St Derfel the Mighty, a famous pilgrimage image of a saint in armour which had just been removed – against strenuous local opposition – from the village of Llanderfel in Wales, was thrown onto a fire at Smithfield in London, after a sermon from Hugh Latimer, Bishop of Worcester. The fire was built around a gallows on which was hanging in chains, still alive, the elderly Observant Franciscan friar, John Forest, who was burnt to death as a relapsed heretic for his refusal to acknowledge royal supremacy over the church.[4]

What these three accounts reveal is that in the space of just six years between 1532 and 1538 a change of seismic significance had occurred: religious heresy and orthodoxy seemed to have changed places.[5] These narratives forcefully remind us that three-dimensional pilgrimage sculptures, often carved in wood – a category now almost entirely lost to us – played a central role in controversies over religion. They demonstrate that in the Middle Ages, particular images were widely believed to have specific supernatural merits and they show that the destruction of such a sculpture was viewed as the ultimate disproof of its allegedly miraculous powers. Our sources lay bare the passionate convictions which motivated iconoclasm and illustrate the terrible punishments used to enforce religious conformity. Finally, they emphasise that by 1538 the king, not the pope, was the supreme head of the church in England.[6]

Up until the 1530s, the destruction of Christian religious sculpture in England and Wales was an heretical crime, usually associated with Lollardy or the radical reform movements sparked by Martin Luther (1483-1546) in main-

land Europe. Since about AD 600 the Christian defence of its religious imagery had been based on letters from Pope Gregory the Great written during an earlier controversy over iconoclasm: 'What writing offers to those who read it, a picture offers to the ignorant who look at it, since in it the ignorant see what they ought to follow, in it they read who do not know letters…That should not be broken which has been set in churches not for adoration but only to instruct the minds of the ignorant.'[7] Pope Gregory's frequently misunderstood arguments for religious imagery became as fundamental to the medieval church as did the Second Council of Nicaea's declaration of AD 787 that the honour paid to an image is passed on to its archetype.[8] During the Middle Ages, three main justifications for religious imagery were conventionally advanced: 'First, for the instruction of simple people, because they are instructed by them as if by books. Second, so that the mystery of the Incarnation and the examples of the saints may be the more active in our memory through being represented daily to our eyes. Third, to excite feelings of devotion, these being aroused more effectively by things seen than by things heard.'[9] Scholastic distinctions were drawn between the types of devotion appropriate to an image and to its prototype, but there was concern about popular failure to distinguish between the image and what it stood for.[10] It was, in particular, devotional figure sculpture which was the subject of worship and which was attacked by heretics.[11]

A powerful onslaught on the extrinsicism and superstition of much later medieval devotion was launched by early-sixteenth-century humanists. Erasmus' *Handbook of the Militant Christian*, for instance, criticised those who venerated particular saints with elaborate ceremonies in the hope that the saint would grant them what they desired or prevent what they feared. Erasmus compared this practice to

ancient Pagan superstition.[12] His *Praise of Folly* poked fun at 'people who have adopted the foolish but pleasurable belief that if they see some carving or painting of that towering Polyphemus, Christopher, they are sure not to die that day'.[13] His witty sarcasm made many impeccably orthodox humanists uneasy about the superstitious practices which were actively encouraged by much late medieval preaching.[14] By the 1520s, there was widespread contention in much of Europe over religious imagery, and iconoclasm was being seriously advocated by some of the Evangelical Reformers.[15] Many criticisms had been rehearsed earlier, during Byzantine iconoclasm, but there were also major new developments, the significance of which has been seriously neglected. Firstly, the developing sense of history which humanism had fostered, and the return to newly edited scriptural texts, tended to highlight the discrepancy between biblical teaching and the contemporary practices of the church. Secondly, the rapid reproduction of texts available with printing, the drive towards vernacular translation and the growth of lay literacy all led to a new emphasis on the *word* of the Bible. Thirdly, there had been a huge growth in the numbers of images and, even more importantly, in the types of sculpture and the way they were used by the medieval church. The affective piety of the late Middle Ages often focused on the individual's intense relationship with the devotional statue. Finally, the Reformers separated the decalogue's first commandment into two, and some now construed the second as ordering an absolute prohibition of religious imagery.[16] Whether or not it is true that 'one man's superstition is another's spirituality', as an eminent Reformation historian has argued, it is certainly the case that one man's – or woman's – worship of an image was, increasingly, another man's superstitious idolatry.[17]

It is clear that it was three-dimensional figure

7.
C.M. Chazelle, 'Pictures, books, and the Illiterate: Pope Gregory I's letters to Serenus of Marseilles', *Word and Image*, vol. 6, no. 2, 1990, pp.138-53; L.G. Duggan, 'Was art really the "book of the illiterate"?', *Word and Image*, vol. 5, no. 3, 1989, pp.227-51. For Byzantine Iconoclasm see D. Freedberg's important essay, 'The Structure of Byzantine and European Iconoclasm', in A. Bryer and J. Herrin (ed.), *Iconoclasm*, Birmingham 1977, pp.165-77. For a wide-ranging study of law and iconoclasm, see C. Douzinas, 'The Legality of the Image', *Modern Law Review*, vol. 63, 2000, pp.813-30. I owe this reference to Professor Lynda Nead.
8.
J. Phillips, *The Reformation of Images: Destruction of Art in England, 1535-1660*, Berkeley 1973, p.14. For Lollard criticisms, see Aston, 1984, p.178. See also Camille, 1989, ch.5.
9.
Duggan, 1898, 232. See also Aston, 1984, pp.181-87.
10.
Aston, 1988, p.31.
11.
Aston, 1984, pp.135-192 (p. 146). The first Lollard iconoclast, William Smith of Leicester, cooked a meal over a burning wooden statue of St Catherine in the 1380s.
12.
J.P. Dolan, *The Essential Erasmus*, New York 1964, *Enchiridion Militis Christiani*, p.60.
13.
Erasmus of Rotterdam, *Praise of Folly and Letter to Maarten van Dorp 1515*, trans. B. Radice, intro. A.H.T. Levi, Harmondsworth 1971, p.63.
14.
M.F. Wakelin, 'A note on preaching, "Roodes and Othyr Ymages" in Mediaeval England', *Downside Review*, no. 103, 1985, pp.76-86; I owe this reference to Miriam Gill. Sir Thomas More's *Utopia*, first published in 1516, described churches that contained 'no visual representations of God, so that everyone was left free to imagine Him in whatever shape he chooses.' See Thomas More, *Utopia*, Harmondsworth 1965, p.125.
15.
M. Baxandall, *The Limewood Sculptors of Renaissance Germany*, New Haven and London 1980, p.70, summarises the arguments of iconoclasts such as Karlstadt and Martin Bucer.
16.
The Lollards had not reached the point of making the decalogue text into a separate second commandment as the reformers of the sixteenth century did. For literacy see M.B. Parkes, 'The Literacy of the Laity', in *Scribes, Scripts and Readers*, London 1991, ch.14.
17.
Haigh, 1988, p.3. Sculpted imagery was commissioned in huge volume right up to the Reformation (see Whiting, 1982, p.3off.; Aston, 1988, p.31).

18.
For example, the Elizabethan homily claiming 'men are not so ready to worship a picture on a wall or in a window, as an embossed and gilt image, set with pearl and stone. And a process of a story painted with the gestures and actions of many persons … hath another use in it, than one dumb idol or image standing by itself' (Aston, 1988, p.405). For cautions as to the meaning of image in inventories, see S. Foister, 'Paintings and Other Works of Art in Sixteenth-century English Inventories', *Burlington Magazine*, vol. 123, 1981, pp.274-5.

19.
Aston, 1988, pp.19-20. C. Bergendoff (ed.), *Luther's Works, Church and Ministry II*, vol. 40, Philadelphia 1958, pp.84ff.; Luther criticised mob destruction of images and distinguished between pilgrimage images which were 'truly idola-trous' and images for memorial and witness which were 'praise-worthy and honourable', in a way which anticipates Henry VIII's distinctions between images. For Holbein, see J. Rowlands, *Holbein*, Oxford 1985, pp.79-80; S. Foister, A. Roy and M. Wyld, *Holbein's Ambassadors*, London 1997, pp.11-12; G.R. Elton, *Reformation Europe 1517-1559*, London 1963, pp.66-7.

20.
Aston, 1988, pp.203-10 (Bucer thought all religious imagery – including paintings – were prone to abuse and should be annihilated); E. Duffy, *The Stripping of the Altars: Traditional Religion in England c.1400-c.1580*, Yale 1992, p.386; *Letters and Papers of Henry VIII*, vol. 9 (1535), p.358. Compare the impact of the English translation of Erasmus's withering satire *Peregrinatio religionis ergo*, c.1536, C.R. Thompson (trans.), *Collected Works of Erasmus, Colloquies*, vol. 40, Toronto 1997, pp.619-74. For the background, see also Tyacke, 1998, pp.4-7.

21.
J. Wilson, 'The Sermons of Roger Edgeworth: Reformation Preaching in Bristol', in D. Williams (ed.), *Early Tudor England*, Woodbridge 1989, pp.223-40; 225-6). Aston, 1988, p.168ff. for the evolution and influence of Latimer's views.

22.
Aston, 1984, p.191. This search for historical precedents – which was to culminate in John Foxe's great *Actes and Monuments* – had other consequences too, such as the beginning of John Leland's antiquarian researches: see his New Year's Gift to Henry VIII, in L.T. Smith, *The Itinerary of John Leland in or about the Years 1535-1543*, vol. I, London 1964, p.xxxviii, where he declares as one objective of his work that 'al manner of superstition and craftely coloured doctrine of a rowte of the Romaine bishopes [be] totally expellid oute of this your most catholique reaulme'.

sculpture which was the focus both of worship and hostility. The word 'image' denoted, primarily, the figure sculpture. Those who were hostile to images often drew subtle distinctions between sculptures which were prone to abuse by being worshipped, and other images which served to instruct and commemorate.[18] Just as fifteenth-century Lollards had done, those who wanted to reform the abuses of images frequently disagreed about what should be done with them, and whether all images should be treated in the same way. Hostility to *some* imagery did not necessarily lead to the *destruction of all* imagery. Issues of public order were always important, as Luther stressed in his rebuke of Andreas von Karlstadt's image destruction at Wittemberg in 1525. State-sponsored iconoclasm subsequently took place in Zwinglian Zurich and elsewhere. Ironically, in view of what later happened in England, iconoclastic frenzy in Basel in 1529 may well have been a deciding factor in Hans Holbein's decision to return to this country.[19]

The arguments of continental iconoclasts rapidly penetrated England through the many contacts with the continent and through the translation (from a Latin edition) in 1535 of Martin Bucer's iconoclastic treatise *Das einigerlei Bild* by William Marshall, one of Thomas Cromwell's clients.[20] These arguments reinforced and developed the views of men such as Hugh Latimer who preached against images in Lent in Bristol in 1533, provoking a furious dispute with the city's conservative clergy.[21] Fifteenth-century Lollard opposition to images was also deployed as a powerful historical precedent by English reformers in the 1530s, when some of the Lollard texts were printed for the first time.[22]

The fundamental change occurred in England and Wales when, in the mid-1530s, the exposure and destruction of pilgrimaged sculptures became government policy, harnessed as an integral part of the undermining and

ridiculing of the whole enterprise of monasticism, and enforced through the new weapons of Royal Injunctions and Visitations. Private acts of clandestine iconoclasm were now succeeded by the theatrical, well-orchestrated and *official* destruction of previously venerated pilgrimage crucifixes and statues of saints. The public exposure of 'frauds' was exploited to justify the Royal Supremacy over the church (from 1534) and the dissolution of the monastic houses (from 1536), in the face of considerable opposition to the early dissolutions of the smaller houses, particularly in the conservative north, but also elsewhere.[23] The unmasking of monastic 'abuses' was intended to prove the hypocrisy of Rome and demonstrate the rightness of the king's renunciation of obedience. It masked the fact that it was for reasons of state – Henry VIII's demand for a divorce from Queen Catherine of Aragon – that the schism had occurred. The commitment to reform of a powerful group around the king, the huge resources of the monasteries, and the fact that they were identified as likely centres of dissent (especially after the Pilgrimage of Grace), helped encourage Henry's doubts about the utility of monasticism. His doubts now seemed to be justified by these revelations about famous pilgrimage images.[24] Apart from the sheer scale of the revolution, it was the speed of change which must have been most astonishing. In March 1538 a candle paid for by the king stood before the image of Our Lady at Walsingham; four months later it was the statue, not the candle, that was burning.[25]

The role of religious sculptures had already been officially undermined in 1536 when their potential for abuse and the dangers of idolatry were expounded,[26] but 1538 saw the decisive move towards authorising their removal. The Second Royal Injunctions began an open attack on those 'feigned images' which were 'abused with pilgrimages or offerings of anything made thereunto', ordering that, 'ye shall,

23.
P. Marshall, 'The Rood of Boxley, the Blood of Hailes and the Defence of the Henrician Church', *Journal of Ecclesiastical History*, vol. 46, no. 4, 1995, pp.689-96. When two craftsmen began to demolish the rood-loft of St Nicholas' Priory, Exeter, they were attacked by a crowd of local women and one of the men had to jump from a tower window in fear of his life: see Whiting, 1982, p.40. For the background, see J.J. Scarisbrick, *Henry VIII*, London 1969, ch.10 and 12.

24.
Letters and Papers of Henry VIII, vol. 13, part 1 (1538). G.R. Elton, *Reform and Reformation: England 1509-1558*, London 1977, p.238. Greg Walker, 'The Image of Dissent: John Skelton, Thomas More and the "Lost" History of the Early Reformation in England', in *Persuasive Fictions: Faction, Faith and Political Culture in the Reign of Henry VIII*, Aldershot 1996, p.173; Walker argues that 'the King's need for allies in his jurisdictional battles with Rome and with his own bishops gave the evangelicals a significance out of all proportion to their numbers or influence to that moment'. See also ch.5, '"Known Men", Evangelicals and Brethren: Heretical Sects in Pre-Reformation England', p.138.

25.
Aston, 1993, p.275.

26.
The sixth of the Ten Articles of 1536, expounds what is a rather negative view of an orthodox medieval position on images: see W.H Frere and W.M. Kennedy (ed.), *Visitation Articles and Injunctions*, vol. II, London 1910, p.5, n.2. A first set of Royal Injunctions issued in the same year promulgated the articles but were substantially more negative (Frere and Kennedy, vol. II, 1910, pp.5-6). As Duffy, 1992, notes (p.393), they explicitly deny the patronage of particular saints for specific needs or benefits, an important break with previous practice.

for avoiding that most detestable sin of idolatry, forthwith take down and delay [withhold and put away] and shall suffer from henceforth no candles, tapers or images of wax to be set afore any image or picture [other than the Rood, Sacrament and Easter Sepulchre] … admonishing your parishioners that images serve for none other purpose but as to be books of unlearned men, that can [know] no letters … which Images if they abuse for any other intent than for such remembrances [of those the images represent], they commit idolatry in the same to the great danger of their souls.'[27]

These Injunctions were ambiguous and inconsistent. Almost any three-dimensional imagery could in principle have been subject to the 'abuse' outlined in the Injunctions. There was no explanation why it was permissible to light a candle in front of a Rood image and not in front of an image such as the Madonna and Child. Ultimately, to distinguish between abused and unabused images was often impossible. Sculptures were thought to work miracles in the medieval church precisely because image and prototype tended to fuse. Indeed, many of the late medieval church's teachings encouraged the belief that images could come to life and that particular sculptures were especially potent.[28] This applied to internationally celebrated images such as that of the Virgin at Walsingham, but also to 'speciality' saints such as St Wilgefortis at St Paul's. She was a beautiful young woman whom God had given a beard to stop her being so attractive to men and thus to preserve her chastity – she was prayed to by wives to rid them of unpleasant husbands, hence her popular name of St Uncumber.[29]

The intensity and scope of the attack on imagery varied from region to region and even from parish to parish as individuals argued which statues were 'abused' by offerings or pilgrimage and whether their removal also entailed their destruction.[30] In Bristol, some townsfolk

27.
Frere & Kennedy, vol. II, 1910, p. 38; Foxe, 1563, p.526.

28.
I have to dissent from Aston's distinction (1988, p. 34) between the 'religion of the people and the intentions of the church'. Many in the church fostered precisely those devotional practices which encouraged superstitious worship of images. For medieval preaching which encouraged such beliefs see Wakelin, 1985, p.79. See also S. Ringbom, 'Devotional Images and Imaginative Devotions', *Gazette des Beaux-Arts*, vol. 73, 1969, pp.159-67.

29.
The only surviving sculpture in England is in the triforium imagery of Henry VII's chapel, Westminster; see J.T. Micklethwaite, 'Notes on the Imagery of Henry the Seventh's Chapel, Westminster', *Archaeologia*, vol. XLVII, 1883, pp.361-80; Vallance, 1947, p.7.

Duffy, 1992, p.415; Haigh, 1988, pp.12-13.

31.
Wilson, 1989, p.231.

32.
Duffy, 1992, p.442. See also Aston, 1988, pp.239-43, for the freer rendering of the Mosaic prohibition of images and for the king's role in retaining imagery.

33.
Phillips, 1973, p.88; Duffy, 1992, p.453; MacCulloch, 1999, pp.7-8. For caveats on the deployment of the term 'evangelical', see Walker, 1996, p.136, and Tyacke, 1998, p.9. For examples of contention and indecision see J. Roche Dasent (ed.), *Acts of the Privy Council 1547-1550*, NS II, London 1890, pp.140-1, 147 and 518.

34.
Dasent, 1890, pp.25-27. In a review of Phillips, F.A. Yates, in her *Ideas and Ideals in the Northern European Renaissance*, London 1984, pp. 45-46, highlights the importance of the implications that the literate layman could now read and memorise the written text and the new significance given to the royal arms. For other contemporary instances of whitewashing interiors and substituting written texts for images see C.S. Knighton (ed.), *Calendar of State Papers Domestic Series of the Reign of Edward VI 1547-1553*, London 1992, pp.77, 78. See also MacCulloch, 1999, p.7-8.

even gave their children the smaller images as toys.[31] During the 1540s, Henry VIII concentrated his efforts on the destruction of all remaining shrines and images which were the object of pilgrimage, but he otherwise deliberately restrained iconoclasm. Indeed, the *King's Book* of 1543 declared that 'although images of Christ and his saints be the work of men's hands only, yet they be not so prohibited but that they may be had and set up both in churches and other places'.[32]

By the time of Henry VIII's death in January 1547, the monasteries had been dissolved, the shrines of saints smashed and pilgrimage statues destroyed. Within a few years, almost the entire population of medieval religious sculpture was to be devastated by the evangelical politicians who formed Edward VI's council.[33] Evidence of a powerful, pent-up desire for change came in outbreaks of unofficial iconoclasm. In February 1547, Protector Somerset and others of the Privy Council examined the wardens and curate of St Martin's in Iremonger Lane, who had removed the Rood and images of the saints 'of their own heddes and presumption, withoute other authorite', setting up in their place scriptural texts 'whereof summe were perversely translated' and substituted the King's Arms for the crucifix.[34]

An ominous portent for the future of traditional imagery came in an exchange of letters between Bishop Stephen Gardiner of Winchester and Protector Somerset. On 3rd May 1547, Gardiner complained to Captain Edward Vaughan that he had heard that 'images of Christ and his sainctes have ben most contemptuously pulled downe' at Portsmouth: 'the destruction of images' he continued, 'conteineth an enterprise to subvert religion and the state of the worlde with it; and specially the nobilitie, who, by images, set forth … their lin(e)age (and) parentage'. Gardiner predicted that attacks on religious imagery would

inevitably extend to heraldry and secular imagery. He then argued that those who smashed them confused the signifier with the signified, neatly turning on its head the reformers' principal objection to the use of images. Images, like words, were signs which could be used for good or ill.[35] The reply, from Protector Somerset, outlined fundamental criticisms of contemporary practices: 'We cannot see my good lord', he wrote, 'but that images may be counted marvailous bokes to whom we kneled, to whom we have kissed, upon whom we have rubbed our beads and handkerchers, to whom we have lighted candels of whom we have asked pardon and help, which thing hath seldom bene done, to the gospel of God or the very true Bible.' Statues, in other words, were the subject of specific abuses which texts were not. Secondly, and even more ominously, he argued that since the whole business of images caused such dissent, it would be better to abolish them all and have done with the matter.[36] The Edwardian Injunctions of Autumn 1547, although based on the Henrician ones, further undermined the role of images by omitting the 1538 description of them as 'the books of unlearned men' and by describing as abused even those images which had only been censed.[37] There was an attempt to control demotic iconoclasm by obliging ecclesiastics 'and none other private persons' to 'forthwith take down, or cause to be taken down and destroy' any images abused with pilgrimage or offering.[38]

On 16 November, the Visitation commissioners ordered the removal of the Rood and all its images from St Paul's in London.[39] A contemporary chronicler relates how 'all images in everie parish church in London were pulled downe and broken' in a systematic campaign of total destruction.[40] Bishop William Barlow echoed Hilsey's histrionic use of the Rood of

35.
J.A. Muller (ed.), *The Letters of Stephen Gardiner*, Cambridge 1933, pp.272-6. Gardiner tried to differentiate the iconoclasts, whom he called Lollards, from Lutheran reformers, who left images intact. The idea that 'just as letters are shapes and symbols of spoken words, pictures exist as representations and symbols of writing' goes back, at least, to Abbot Gilbert Crispin of Westminster (see M. Camille, 'Seeing and Reading: Some Visual Implications of Medieval Literacy and Illiteracy', *Art History*, vol. 8, 1985, p.32).

36.
Phillips, 1973, pp.91-2. Foxe, 1563, p.730: 'better it wer for a tyme to abolish them al'.

37.
Duffy, 1992, p.450. No lights were to be set before any images and censing was not allowed at all, whereas previously people had been instructed that censing was only to what the image venerated, not to the image itself. Aston, 1988, p.256. As Miriam Gill has pointed out to me, this would include every statue of the Virgin and patron saint, for the Sarum Rite required that such images be censed on Sundays and feast days.

38.
Frere and Kennedy, vol. II, 1910, p.116. They were ordered to 'take away, utterly extinct and destroy all shrines … pictures, paintings and all other monuments of feigned miracles, pilgrimages, idolatry and superstition; so that there remain no memory of the same in walls, glass-windows or elsewhere.' See Duffy, 1992, pp.451 and 480; Foxe, 1563, p.688.

39.
Hamilton, 1877, p.1.

40.
Hamilton, 1877, p.1; Duffy, 1992, p.454: the walls were whitewashed and painted with texts against idolatry.

41.
Hamilton, 1877, p.1; Aston, 1993, p.282; MacCulloch, 1999, p.71. Barlow also stood an image of the Virgin, which had been unsuccessfully hidden from the visitors, in front of his pulpit: it too was smashed.

42.
MacCulloch, 1999, pp.72-3. At Long Melford in Suffolk, the imagery of the high altar was defaced and sold as scrap to a goldsmith whilst numerous alabaster images were sold to a local gentry family, who may have been protecting them from destruction. D. Dymond and C. Paine, *The Spoil of Melford Church: the Reformation in a Suffolk Parish*, Ipswich 1992, p.39, n.91.

43.
MacCulloch, 1999, pp.29 and 32.

44.
The phrase is borrowed from MacCulloch, 1999, p.9. See also Duffy, 1992, p.469.

Boxley in a sermon on the abominable sin of idolatry. He theatrically displayed a jointed image of Christ from an Easter Sepulchre 'which putt out his legges of sepulchree and blessed with his hand, and turned his heade'.[41] This must have been an articulated image of a type used during the traditional Easter ceremonies: now, removed from that context, it could easily be made to look ridiculous. Throughout the country images were burnt or defaced, often on local initiatives.[42] The young king Edward VI was, himself, distinctly in favour of purging churches of 'idols and devils'.[43] And then, in January 1550, in what has appropriately been termed a 'dynamic assault on the past', an Act for the defacing of images and the bringing in books of old Service in the Church ordered the destruction *of each and every image* 'of Stone, Tymbre, Alleblaster or Earthe [clay or terracotta], graven, carved or paynted, whiche heretofore have bene taken out of anye Churche or Chappell or yet stande in anye Churche or Chappell'.[44] This was a revolution to purify the present by totally obliterating the past. Or, more precisely, to recover an earlier and 'purer' Christian past, the deformations of the medieval church had to be swept away.

In the space of less than fifteen years, an attack on 'abused' images had mutated into an onslaught on virtually all religious sculptures. The formerly heretical view that Christian images were deceitful idols became the new orthodoxy, and what had before been conventional piety was proscribed. To propagate this radical reappraisal of the value of the image, effective evangelical sermons, the support of elite continental Reformers and the power of the printing press were all deployed: the contentious translation of the Latin 'imago' as the negative 'idol' rather than the more neutral 'image' in the vernacular Great Bible of 1538 certainly undermined conservative defence of

religious images.[45] Above the chancel arch, the royal arms of the king now replaced the vanished Roods, emphasising 'an essential feature of the Edwardian Reformation: it was a revolution directed from above, by the monarch, his council and the Parliament at Westminster'.[46]

One critically important item in the 1550 Act had repercussions which have never been properly considered. In condemning *all* religious images, it specifically exempted tomb monuments.[47] The mere fact that this decree sought to prevent iconoclasm extending to tomb monuments shows that they were already being attacked. It must have appeared anomalous that monuments, which might have tomb-chests covered with images of saints, should be exempted. Indeed, Bishop John Hooper's articles for Gloucester and Worcester dioceses in 1551-2 went beyond the Royal Injunctions in ordering the removal of all 'tabernacles, tombs, sepulchres … Roodlofts … where superstition, idols, images or other provocation of idolatry have been used'.[48] There may also have been, as Diarmaid MacCulloch has suggested, a desire to efface the effigies of clergy in eucharistic vestments and the insistent requests for prayer in the inscriptions.[49] Iconoclasm had not extended to secular imagery and heraldry; on the contrary, the traditional religious imagery which appeared not only on clerical monuments but also on those of the laity was the target and the whole issue of the status of secular sculpture was, as Sydney Anglo has shown, simply evaded.[50]

Margaret Aston has argued that the destruction of religious imagery was to remain a central, distinctive and recurring feature of the Reformation in England and Wales.[51] This is, of course, to use the term 'Reformation' to cover not just the Reformation under Henry VIII and Edward VI, but also that under Elizabeth I, often termed the 'Second Reformation', and, in

addition, the phase of Puritan dominance in the seventeenth century. It can be objected that such a use of the word gives an unjustified impression of inevitability to the historical progress of Protestantism. Moreover, if the term is used to cover more than a century's developments, it is not surprising that the destruction of religious imagery was, like the process of Reformation itself, necessarily a complicatedly mutating and recurrent phenomenon rather than a continuous process. Destruction was halted and reversed under Queen Mary (1553-8), when most parish churches acquired a Rood with figures of Mary and John and a statue of the patron saint.[52] Archdeacon Harpsfield's Visitation of Kent in 1557 required a carved statue of the patron saint and a carved Rood with St Mary and St John, each of the figures at least 1.5m high, in every parish church, a reintroduction of medieval requirements.[53] Some of the images which had been sold or hidden from the Edwardian commissioners reappeared in the churches.[54] Even under Queen Mary, though, the copious sculptures of saints and the multiple figures of the Virgin which once decorated every church, could not be generally replaced. Some aspects of traditional religion – such as chantry benefactions – had been decisively weakened when proscribed by Edward VI, and even if there was a will to replace religious images, the process of replacement was slow and expensive. By contrast, the destruction of half a millenium's images had been speedy and cheap.[55]

Iconoclasm dramatically accelerated again in the early years of Queen Elizabeth's reign (1558-1603); despite the queen's resolute defence of images as things indifferent and not idols unless abused by misdirected worship, her bishops succeeded in imposing a more resolutely anti-iconic policy.[56] Protestant sensitivity to

45.
Wilson, 1989, pp.229 and 235.
46.
MacCulloch, 1999, p.163.
47.
Phillips, 1973, p.97; A. Luders et al., *Statutes of the Realm*, London 1810-28, vol. IV, p.111: 'This Acte or any thing therin conteyned shall not extende to any Image or Picture sett or graven upon any tombe in any Churche Chappell or Churche Yard onlye for a Monument of any Kinge Prince or Nobleman or other dead person, whiche hath not bene comonly reputed and taken for a Saincte.'
48.
Frere and Kennedy, vol. II, 1910, pp.284-5.
49.
D. MacCulloch, 'The Myth of the English Reformation', *Journal of British Studies*, vol. 30, 1991, p.12.
50.
S. Anglo, *Images of Tudor Kingship*, London 1992, ch.1.
51.
Aston, 1993, p.261; MacCulloch, 1991, p.12. See also P. Collinson, 'Comment on Eamon Duffy's Neale Lecture and the Colloquium', in Tyacke, 1998, pp.71-86.
52.
Duffy, 1992, p.545 and 547: There was also some official Marian destruction of painted imagery: images or texts which attacked fasting, clerical celibacy, the value of good works or the veneration of the Blessed Sacrament were to be blotted out.
53.
Duffy, 1992, p.556; simultaneously, numerous Protestants were burned for their beliefs.
54.
For example, Dymond and Paine, 1992, p.59, for donations at Long Melford of two alabaster images and a painted panel in 1556 which had probably been acquired under Edward VI; see Duffy, 1992, pp.478-503. For an assessment of Mary's achievement, see D.M. Loades, *Mary Tudor. A Life*, Oxford 1989, p.248; R. Hutton, 'The Local Impact of the Tudor Reformations', in Haigh, 1987, pp.114-38. For caveats, see Tyacke, 1998, pp.21-2.
55.
Duffy, 1992, p.563. cf. the purchases of a rood and companion images at Long Melford in 1556 and their painting the same year (Dymond and Paine, 1992, pp.62 and 63). Bishop Gardiner's chantry chapel at Winchester is notable for the absence of sculpted imagery of saints such as covered the chapels of his predecessors: instead, the two sculptures represent Synagogue and Ecclesia, essentially allegorical figures which would not provoke Protestants.
56.
MacCulloch, 1991, p.11-13.

the wrongful use of visual imagery had been greatly increased by twenty years of bitter contention and the reintroduction of imagery under Queen Mary was an obvious symbol of the realm's renewed subjection to Papal authority. In 1559, Royal Injunctions reiterated the Edwardian requirement for the destruction of 'abused' imagery and the Marian Roods were burnt.[57] Although unabused imagery was tolerated in theory, the articles for enquiry regarded all images as causes of idolatry and ensured their destruction. It was only when Visitation committees started to destroy tombs and images of the nobility that there was a reaction.[58] In September 1560 Elizabeth issued a proclamation against the destruction of tombs and monuments by people 'partly ignorant, partly malicious or covetous': the monuments were intended 'only to shew a memory to the posterity of the persons there buried … and not to nourish any kinde of superstition'.[59]

Hostility to three-dimensional religious imagery – though not necessarily to all religious imagery in two dimensions – was accelerated by publication of the *Second Book of Homilies*, with its three sections on idolatry, and by the first edition of John Foxe's great *Actes and Monuments* in 1563. However, Foxe's argumentative tone makes it quite clear that there were powerful dissenting voices; some medieval sculptures were hidden and Visitation orders to destroy them were neglected.[60] It would be astonishing if it had been otherwise, given that the medieval image heritage had been so massively rich, the belief systems which were being changed were so deeply ingrained and the mechanisms for changing them so imperfect. In Wales in 1567 the Bishop of Bangor found 'images and altars standing in churches undefaced … much pilgrimage and many candles set up to the honour of saints'.[61] One recusant, Roger Martin, writing in the 1580s or 1590s, provides a moving description

of the church of Long Melford prior to the Reformation: he still had a reredos showing the crucifixion and two thieves 'in my house, decayed and the same I hope my heires will repair and restore again, one day'.[62] Tessa Watt has argued that we should be careful about locating a cultural watershed in the 1580s and that iconoclasm did not necessarily lead to iconophobia.[63] By this time, though, the arguments over religious imagery were increasingly about two-dimensional representations: the majority of all religious sculpture had already been destroyed.[64]

In the 1620s and 1630s, Archbishop Laud and his followers reintroduced religious imagery, including sculpture, into churches as for example at Peterhouse College, Cambridge, where the new chapel was furnished with large statues of the four Evangelists in 1638.[65] At about this time, William Dowsing, shortly to become the most notorious iconoclast in English history, moved into a Suffolk village just across the river from Dedham, whence three of the Dovercourt iconoclasts had set out in 1532. This area, a hotbed of iconoclasts in the 1530s, was still, a century later, a centre for those who wished to purify the church of Laudian idolatry.[66] The final, devastating period of official iconoclasm took place during the Civil War. On 24 April 1643, the Commons appointed a committee to demolish monuments of idolatry and superstition in Westminster Abbey and any other church of chapel in London: one of its victims in 1644 was Pietro Torrigiano's great High Altar and reredos in Henry VII's chapel, but the statuary of the chapel's exterior seems, astoundingly, to have survived until 1712 when it was removed 'lest the Ministry should be injured'.[67] The first parliamentary ordinance for the demolishing of the monuments of Idolatry was published on 28 August 1643, followed by a second on 9 May 1644. On 19 December 1643, William Dowsing was appointed as the

57.
Phillips, 1973, p.116. Frere and Kennedy, 1910, vol. III, pp.9 and 16.

58.
Phillips, 1973, p.117, citing W.P.M. Kennedy, *Elizabethan Episcopal Administration*, vol. 1, London 1924, pp.lxii-lxiii. Aston, 1993, p.305.

59.
Phillips, 1973, pp.117-18; P.L. Hughes and J.F. Larkin (ed.), *Tudor Royal Proclamations II*, London 1969, pp.146-8. John Weever, *Ancient Funerall Monuments*, London 1631, pp.54ff.; John Stow, *A Survey of London*, London 1908, vol. 1, pp.135, 195, 193, 204ff., for destruction and defacement of tombs.

60.
Hutton, 1987, pp.135. At Long Melford, the Marian rood and its imagery were only destroyed in 1561-2 (Dymond and Paine, 1992, pp.74-5). R. Whiting, '"For the Health of my Soul": Prayers for the Dead in the Tudor South-West', *Southern History*, vol. 5, 1983, pp.68-94. For Foxe's impact, see D. Loades (ed.), *John Foxe and the English Reformation*, Aldershot 1997.

61.
Phillips, 1973, p.134; *Calendar of State Papers, Domestic*, Elizabeth, vol. XLIV, p.301 (27) (7 October 1567).

62.
Dymond and Paine, 1992, p.2.

63.
T. Watt, *Cheap Print and Popular Piety 1550-1640*, Cambridge 1991, p.131ff.; cf. P. Collinson, *From Iconoclasm to Iconophobia: the Cultural Impact of the Second English Reformation*, Reading 1986.

64.
The evidence from inventories cited by Watt, 1991, p.134 (S. Foister, 'Paintings and Other Works of Art in Sixteenth-century English Inventories', *Burlington Magazine*, vol. 123, 1981, pp.273-82) actually contradicts the argument for 'cultural continuity right through the Edwardian years to the early part of Elizabeth's reign'.

65.
T. Cooper, 'Dowsing at Cambridge University', in Cooper (ed.), *The Journal of William Dowsing: Iconoclasm in East Anglia during the English Civil War*, Woodbridge 2001, pp.49 and 159-60. See also Laud's defence in Loades (ed.), 1997, p.74.

66.
J. Morrill, 'William Dowsing and the administration of iconoclasm in the Puritan revolution', in Cooper (ed.), 2001.

67.
J.T. Cliffe, *Puritans in Conflict: the Puritan Gentry during and after the Civil Wars*, London 1988, p.135; H.M. Colvin (ed.), *The History of the King's Works*, vol. III, Part 1 1485-1660, London 1975, pp.221-2.

Earl of Manchester's commissioner for removing the monuments of idolatry and superstition from the churches of Cambridgeshire and Suffolk, to implement the parliamentary ordinance.[68] The ordinance required the destruction of 'all Crucifixes, Crosses and all Images and Pictures of any one or more Persons of the Trinity or of the Virgin Mary, and all other Images and Pictures of saints'; Dowsing, carrying with him his 1641 edition of Foxe's *Actes and Monuments*, made every effort to enforce it.[69]

Fortunately for the survival of some medieval imagery, Dowsing's particular commission seems to have been unique (though Richard Culmer also acted on commission at Canterbury Cathedral). There is, however, copious evidence of other contemporary destruction throughout England and Wales, by local parish officers or by Parliamentary soldiers often exceeding the instructions of both the 1643 and 1644 Ordinances, which explicitly excluded, in terms familiar from the previous century, 'any Image, Picture, or Coat of Arms in Glass, Stone or otherwise ... set up or graven onely for a Monument of any King, Prince, or Nobleman, or other dead Person which hath not been commonly reputed or taken for a Saint ... All such Images, Pictures and Coats of Arms may stand and continue.'[70] Anxieties about the potential defacing of a monument to their only child by misguided soldiers are evident in the inscription of a monument from 1646 at Marholm, near Peterborough (where, in the cathedral, tomb monuments had just been extensively vandalised). Beneath a small bust of the boy and a coat of arms borne by two little cherubs is an inscription 'To the courteous Souldier':

Noe crucifixe you see, noe Frightfull Brand
of super[s]tition's here, Pray let mee stand.[71]

Much was to change again after Charles II's restoration (1660), but, by the middle of the seventeenth century, iconoclasm in England and Wales had produced a deep and enduring suspicion of all three-dimensional religious imagery, now tainted by association with Rome and Popery: Christian images had become Roman idols.[72] Official iconoclasm had emphasised secular control over the church of England. It had manifested the triumph of the printed, vernacular, Biblical Word over claims that the sculpted image could mediate between man and God. It was based on a scrutiny of God's Word transmitted through newly edited scriptural texts, rather than on a respect for the authority and traditions of the medieval church. It had enforced a massive narrowing of the range of artistic production in this country and an increased concentration on secular work.[73] Iconoclasm, in short, had reduced the brightly-painted, image-encrusted churches of medieval Britain to white or grey boxes in which a purified religion could be safely preached and read. And it had resulted in the destruction or defacement of almost the entire output of medieval religious sculpture in Britain.

68.
Morrill in Cooper (ed.), 2001, p.13.
69.
Cooper, 2001, p.342.
70.
Cooper, 2001, p.343. See also D. Nussbaum, 'Appropriating Martyrdom. Fears of Renewed Persecution and the 1632 Edition of Foxe's *Actes and Monuments*', in Loades, 1997, pp.178-91.
71.
The transcription in R. Walker, 'William Dowsing in Cambridgeshire', in Cooper, 2001, p.39, is corrected here.
72.
The nineteenth-century repopulations of the great screens at St Albans and Winchester generated considerable controversy and the restorers did not dare polychrome the new statuary.
73.
N. Llewellyn, *The Art of Death: Visual Culture in the English Death Ritual*, London 1991, pp.122-3, points out that allegorical figures and symbolic figures, e.g. of Death, are found on Elizabethan tomb monuments: they were permitted 'because they were not representations of religious figures and because they were intended to act as examples to the onlooker'. See also Llewellyn, 'The Royal Body: Monuments to the Dead, for the Living', in L. Gent & N. Llewellyn, *Renaissance Bodies*, London 1990, pp.218-40. In discussing Elizabethan monuments, he makes the important point that with the abolition of Purgatory, 'the Reformed dead had been carried beyond the influence of the living' (p.222). See also Duffy, 1992, p.475.

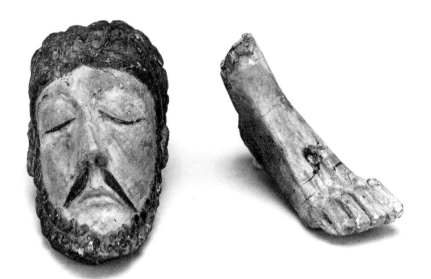

Two fragments of a Crucifix
*c.*1130 [19]

1.

L. Stone, *Sculpture in Britain: the Middle Ages*, Harmondsworth 1972, p.2, agrees that well over 90 per cent of English medieval religious imagery has been destroyed: my unscientific sampling of some major buildings suggests that the loss rate is even greater than Stone thought. Llewellyn, 1991, p.121, makes the provocative claim that 'Victorian reformers were responsible for more damage than their radical Protestant forebears.'

2.

They were particularly at risk if they were in former monastic churches, although some powerful families tried to preserve the buildings or move their monuments; this happened, for example, when the third duke of Norfolk brought some of the Howard tombs from the dissolved Cluniac Priory of Thetford to Framlingham parish church, where the chancel was rebuilt as a dynastic mausoleum. See P. Lindley, 'Inno-vations, Tradition and Disruption in Tomb Sculpture', in D. Gaimster and P. Stamper (ed.), *The Age of Transition: The Archaeology of English Culture 1400-1600*, Oxford 1997, pp.77-92.

3.

M. Whinney, *Sculpture in Britain 1530-1830*, Harmondsworth 1964, pp.1-3, for a damning indictment of English (sic) sixteenth-century art in general and sculpture in particular.

4.

Dynastic loyalties were of great importance when merit was thought to run down the blood lines; family honour might demand that respect was paid to ancestral tombs. On the other hand, the Dacre family tombs were left unprotected in the roofless east end of Lanercost Priory: see P. Lindley, 'Heraldic Tomb-Monuments', in H. Summerson, S. Harrison et al., *Lanercost Priory, Cumbria, Cumberland and Westmorland Antiquarian and Archaeological Society Research Series*, no. 10, 2000, pp.153-66. For the destruction of tombs in Lincoln Cathedral see G. Zarnecki, J. Holt and T. Holland (ed.), *English Romanesque Art 1066-1200*, London 1984, p.146. This was also a period when families might fake ancestors' effigies or even fake the ancestors in order to buttress their own standing.

5.

P. Lindley, 'Absolutism and Regal Image in Ricardian Sculpture', in D. Gordon, L. Monnas and C. Elam (ed.), *The Regal Image of Richard II and the Wilton Diptych*, London 1997, pp.61-83. T. Cavanagh and A. Yarrington, *Public Sculpture of Leicestershire and Rutland*, Liverpool 2000, pp.273-6.

6.

For this see, most recently, Zarnecki, 1984, p. 160.

III　FROM ROMANESQUE TO REFORMATION

In a long holocaust of images, the teeming populations of medieval intercessory sculptures had been exterminated by 1650. Indeed, the huge majority of *all* medieval religious figure sculpture in England and Wales had been destroyed.[1] Many tomb monuments had also been destroyed or defaced.[2] This was in spite of the fact that they had been protected by law, and monumental sculpture was to form the major arena for sculptural production in the later sixteenth and most of the seventeenth centuries.[3] Powerful social elites had a vested interest in ensuring that religious revolution did not precipitate a social one.[4] Although secular sculpture did exist – for example the images of kings from Westminster Hall or on the exterior of Stapleford Hall, Leicestershire, both examples of a profound regard for ancestry, it was only ever a tiny minority of medieval sculptural production.[5]

It is a consequence of the 'Long Reformation' that some categories of sculpture, once to be seen in every church in the country, have virtually disappeared. The earliest objects in this exhibition are fragments of a now unique, if partial, survivor. All that remains of what must have been a Romanesque wooden crucifix originally about 80 cm in length and dating from *c.*1130, from South Cerney in Gloucestershire, are Christ's head and a foot, now preserved, bizarrely, like the relics of a medieval saint.[6] These remains were discovered in September 1913, immured near the northern springing of the western tower arch in a hollow space behind the face of the wall. They appear to have been intentionally hidden, probably between 1547 and 1553, when state policy

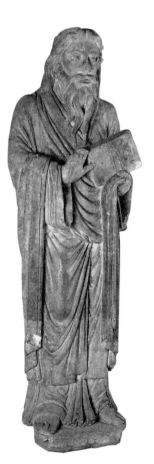

7.
W.R. Lethaby, in *Proceedings of the Society of Antiquaries*, vol. 27-8, 1915-16, p.17; A.C. Stephens, 'Particulars as to the Discovery of Head in South Cerney Church near Cirencester', p.18. They were in a very fragile condition, and have been conserved by the British Museum laboratory, which restored Christ's nose in 1960.
8.
A. Vallance, *English Church Screens: Being Great Roods, Screenwork and Rood-Lofts of Parish Churches in England and Wales*, London 1936, p.12. Throughout the Middle Ages, it was a great privilege to be buried before an image of the crucified Christ, to benefit from its Holy presence: Vallance, *Greater English Church Screens: Being Great Roods, Screenwork and Rood-Lofts in Cathedral, Monastic and Collegiate Churches in England and Wales*, London 1947, p.3, for examples. Some were miracle-working from the start, such as the nearly contemporary example consecrated at Bury St Edmunds in 1107 by St Anselm, Archbishop of Canterbury, which had miraculously split itself off from the timber out of which it was being carved.
9.
Zarnecki, 1984, p.160, discusses this.
10.
The abbey had been dissolved in November 1539 and within half a dozen years the entire church was roofless; in 1550 the gravestones and brasses were sold off. See D.M. Palliser, 'The Reformation in York 1534-1553', *Borthwick Papers* no. 40, 1971; C. Norton, 'The Buildings of St. Mary's Abbey, York and their Destruction', *Antiquaries Journal*, vol. 74, 1994, pp.256-88, with full bibliography.
11.
S. Oosterwijk, 'Late Twelfth-Century Figure Sculpture in Yorkshire', unpublished MA dissertation, University of York 1988, p.18.
12.
C. Wilson, 'The Original Setting of the Apostle and Prophet Figures from St. Mary's Abbey, York', in F.H. Thompson (ed.), *Studies in Medieval Sculpture*, London 1983, pp.100-21.

turned towards the total destruction of such images. At less than half life-size, the crucifix seems small to have come from a Rood – the image of the crucified Christ, customarily flanked by images of St Mary and St John – such as was ubiquitous in all churches, suspended or supported over the east end of the nave.[7] However, the location in which it was immured strongly suggests that it was indeed a Rood.[8] The Rood figure was a stringently stylized representation of the dead, not the triumphant Christ; it emphasised the agony of His sacrifice rather than His triumph over death. The stylistic origins of the sculpture – with its rope-like hair carved in long tresses over the head, the formulaic whorls of the beard and large moustache – have been described as Spanish or German.[9] Throughout the Middle Ages, sculpture in England and Wales was both directly and indirectly influenced by continental imagery, as is the case with the pair of life-size figures from St Mary's Abbey, York.

In January 1829 seven figures were excavated by workmen amongst the ruins of the church of St Mary's Abbey, once the richest Benedictine monastery in northern England.[10] The statues had been buried under foundations in the nave. Their excavator, Charles Wellbeloved, romantically assumed they had been 'carefully concealed by some one whose good taste and feeling had not been overpowered by religious zeal'.[11] Today it is usually thought that the statues had been reused as foundations for an Elizabethan building. Given that the whole Romanesque church had been rebuilt from the ground between 1271 and 1294, the statues, it is claimed, had either been re-employed in the thirteenth-century church or belonged to an ancillary monastic building which survived in its original Romanesque form until the Dissolution.[12] Nearby York Minster provides an example of Gothic reuse of earlier sculptures. There, statues from the west front of the

Romanesque church were reused in the first half of the fourteenth century, when the earlier church was rebuilt.[13] Two of these statues, damaged by exposure to the elements from the twelfth century until the 1960s when they were removed, are exhibited here alongside the St Mary's figures for the first time.

The argument that the St Mary's figures were also reused on the exterior of the 1271-94 church is undermined by the absence of any credible context for them and by the suggestion that their original polychromy – which was remarkably well preserved when they were first excavated – remained in too good a condition for them to have been exposed to the English weather for three-and-a-half centuries. Accordingly, it has been suggested that their reuse was inside the new church, possibly on the choir screen.[14] An alternative view is that they came from Romanesque monastic buildings such as the chapter house, which survived intact up until the Dissolution. Two respected theories dispose them around the chapter house, in one case extending the programme into the chapter vestibule, and in the other arranging the figures in two tiers inside the chapter house itself.[15]

Central to all these theories has been the view that the statues survived intact up to the Dissolution. Recently, however, it has been suggested that they were already reused as foundation material during the rebuilding of the church in 1271-94.[16] There are many medieval parallels for such casual destruction.[17] The twelfth-century statues of York Minster may have been retained by Gothic masons for reasons of economy not respect: they were all reused high up on the newly rebuilt church, where they would not have been too noticeable from the ground. If the St Mary's Abbey figures were actually cannibalised as foundation rubble in the late thirteenth century, then perhaps the statues originally belonged to a

13.
S. Oosterwijk and E.C. Norton, 'Figure Sculpture from the Twelfth-Century Minster', *Friends of York Minster Annual Report*, York 1990, pp.11-30. This important paper deserves to be better known. See also E.C. Norton, 'The Stone which the Builders Rejected', and S. Oosterwijk, 'York Minster', in B. Heywood (ed.), *Romanesque: Stone Sculpture from Medieval England*, Leeds 1993, pp.8-17 and 50-60.

14.
R. Marcousé, *Figure Sculpture in St. Mary's Abbey, York*, York 1951, p.5; A.B. Whittingham, 'St Mary's Abbey, York: an interpretation of its plan', *Archaeological Journal*, vol. 128, 1972, p.126, though he mistakenly thought they were repainted in the late thirteenth century.

15.
G. Zarnecki, *Royal Commission on Historical Monuments, Outside the City Walls, East of the Ouse*, vol. IV, London 1975, pp.xliii-xliv, 23-4, argued that twelve figures of the apostles were located in the chapter house and statues of Old Testament prophets were placed marking the bay divisions in the vestibule. Christopher Wilson proposed that twenty-four figures were located in the chapter house, with the Old Testament prophets supporting the Apostles above them.

16.
Norton, 1994, p.275-8. This was the view expressed by E.S. Prior and A. Gardner, *An Account of Medieval Figure-Sculpture in England*, Cambridge 1912, p.215.

17.
At Lincoln Cathedral, for instance, the twelfth-century façade relief programme was partly destroyed in the thirteenth century by the insertion of a large window: G. Zarnecki, *Romanesque Lincoln: The Sculpture of the Cathedral*, Lincoln 1988, p.71. See also the reuse of the Romanesque cloister capitals at Norwich as building stone in the fourteenth century: A. Borg, J. Franklin, V. Sekules, T. Sims and D. Thomson, *Medieval Sculpture from Norwich Cathedral*, Norwich 1980, pp.7ff.

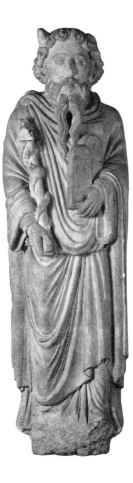

Moses *c.*1200 [I]

French-inspired portal programme as our installation suggests:[18] the style of the figures is certainly influenced by French models.[19] Portals adorned with column figures were one of the chief areas of sculptural embellishment on French Gothic churches and this French disposition of statuary was widely followed throughout Europe, although it was never very popular in England.

One of the two figures is identifiable as Moses by the tablets of the law and the brazen serpent as well as by his horns which were thought to be his attribute because of the Vulgate mistranslation of the Hebrew 'rays of light'.[20] The other figure is bearded and moustached, and his long hair coils, rope-like, over his forehead. He is bare-footed and carries a book in his left hand, his right raised in blessing: these details suggest that he represents an apostle. The original programme included the Apostles and Old Testament forerunners of Christ, on one or more portals.[21] The St Mary's programme of *c.*1200 would have been a striking innovation in England, one which never had a significant successor, and which was, evidently, not much valued even in York by the 1270s.

The York Minster figures, by contrast, did not come from a portal: the backs of the figures are curved but flat (whereas some of the abbey statues have columns at their backs) and they probably stood in niches ranged across the minster's west façade.[22] The identity of individual figures is difficult to determine. The statue of a woman with a circlet and scroll is of superb quality in spite of its eroded condition. The image has been thought to represent the Queen of Sheba. The same sculptor was surely responsible for the very weathered, but still evocative, beardless male figure, who carries a now obliterated book and should probably be identified as a young apostle (such as St John the Evangelist): apostles are generally shown holding books in this period, whilst Old Testament

18.
Prior and Gardner, 1912, p.216 for the tentative suggestion that there were two portals and p.217 for a connection with Spain; Stone, 1972, p.101; Norton, 1993, p.14.
19.
W Sauerlander, 'Sens and York', *Journal of the British Archaeological Association*, vol. 22, 1959, pp.53-69.
20.
Numbers 21 vs.8-9. 'And the Lord said to Moses, Make thee a fiery serpent and set it upon a pole: and it shall come to pass, that every one that is bitten, when he looketh upon it, shall live. And Moses made a serpent of brass, and put it upon a pole, and it came to pass, that if a serpent had bitten any man, when he beheld the serpent of brass, he lived'. St Jerome mistranslated 'rays of light' in Exodus xxxiv vs.29 as 'horns'.
21.
Sauerländer, 1959, p.58.
22.
cf. Wells: Stone, 1972, pp.108-12.
23.
G. Zarnecki, 'Two Late Twelfth-century Reliefs in York Minster', in Zarnecki, *Studies in Romanesque Sculpture*, London 1979, ch.xvi; Norton, 1993, p.15, provides a reconstruction incorporating the surviving symbols of the Evangelists. The programme from the minster's west front may have illustrated the triple division of salvation history: Old Testament patriarchs and kings; the Apostles; and the Christian church, all gathered round a lost central image of Christ in Majesty. Perhaps the female figure once pointed up to this central composition?
24.
Oosterwijk, 1988, pp.53-4.
25.
Norton, 1993, p.9.
26.
A. Brodrick, 'Painting Techniques of Early Medieval Sculpture', in Heywood, 1993, pp.18-27.

figures carry scrolls.[23]

The Minster's and St. Mary's statues do not appear to be the product of the same sculptural shop. There are many differences in detail: the physical flatness of the Minster figures, but their more mobile poses, gestures and head movements, all differentiate them from the St Mary's images, which instead have a rather ponderous weight and solemnity.[24] The large numbers of surviving images from this period in and around York strongly argue for the presence of a substantial number of specialist figure sculptors in the city by the end of the twelfth century. When the St. Mary's figures were first excavated in 1829, they were described as 'splendidly coloured and gilt...The beard of the Moses has been richly gilt... [but] ... the action of the air upon the gilding soon caused its extreme brilliancy to fade.'[25] The survival of paint on St Mary's figures[26] and on the South Cerney crucifix reminds us that wooden and stone sculpture alike were generally highly painted in the Middle Ages. There was, however, a great sensitivity to the sculptural medium. The employment of Tournai and Purbeck 'marbles' shows how these materials, actually limestones which could take a high degree of polish, were valued for their surface and colour: paint or gilding might be used selectively. A fragment of a lavabo or laver (a structure in which the monks could wash their hands) from Much Wenlock Priory in Shropshire, is carved from the local limestone known as 'Wenlock marble'. This panel, representing Christ calling St Peter, was dug up in 1878. It is of a similar date to the St. Mary's and York Minster statues – *c.*117-1200 – and shows Christ, identifiable by his cruciform nimbus, calling St Peter, whose hands he clasps, and St. Andrew, whilst they are fishing in the Sea of Galilee. A second boat, above, contains St James and the superbly mannered figure of St. John, his head turned at an extraordinary

27.
Zarnecki, 1984, p.201.
28.
Zarnecki, 1984, p.201.
29.
For these effigies, see Prior and Gardner, 1912, pp.603 and 630, where they are described as inexpert copies of Purbeck marble effigies of *c.*1240; J.W. Hurtig, *The Armored Gisant before 1400*, New York 1979, p.116, views them as early, dating them to 'the second quarter of the thirteenth century and certainly not after *c.*1250'; H.A. Tummers, *Early Secular Effigies in England: the Thirteenth Century*, Leiden 1980, p.137, on the other hand, dates them to *c.*1250-75. T.A. Beck, *Annales Furnesienses*, London 1844 (the plates are extremely inaccurate); see also W.H. St J. Hope, 'The Abbey of St Mary in Furness', *Lancashire Transactions Cumberland and Westmorland Antiquarian and Archaeological Society*, vol. 16, 1900, pp.221-302. A rather flat effigy of an ecclesiastic is carved from the same material but later effigies were carved in the local sandstone.
30.
Tummers, 1980, p.18. See also Prior and Gardner, 1912, p.601.
31.
The monks of Furness were implicated in the Pilgrimage of Grace, the revolt against the suppressions of the smaller monasteries, and the last abbot, Roger Pyle, surrendered his house to the king to avoid charges of treason on 5 April 1537. Furness thus became the first of the major monasteries to be dissolved. J. Wood, 'History', in S. Harrison et al., *Furness Abbey*, 1998, pp.29-30. Cook, *Letters to Cromwell*, pp.128-9.
32.
D. Postles, 'Small Gifts, but Big Rewards: the Symbolism of Some Gifts to the Religious', *Journal of Medieval History*, vol. 27, 2001, pp.23-42. See L.R. Ayre, *Notes on Furness Abbey*, Ulverston n.d (*c.*1902²), p.36.

angle as he gazes at Christ. The rowing of the boats towards the strong figure of Christ and the remarkable action in which Christ grasps St Peter's hands, endows this scene with a powerful drama. The whole narrative is enclosed within a trefoil-headed arch, above which are sprigs of foliage; this was part of a large scheme of panels round the base of the lavabo.[27] The style of the sculpture has been connected with Mosan enamels.[28] It was certainly gilt and painted, at least partially, for St John's hands are barely articulated and the fingers must have been more precisely distinguished in paint: the sculptor focused on the lower boat and the important action.

Two thirteenth-century effigies of knights from the Cistercian abbey of Furness in Lancashire are carved from a local substitute for Purbeck marble (widely employed for effigial sculpture).[29] These figures, remarkable for their schematic and stylised handling, have no indication of the mail on their legs or arms, which may have been indicated by stamped gesso.[30] Increasingly, lavish polychromy undermined the use of 'marbles' later in the century. Any such details were lost when the effigies were damaged following the dissolution of the abbey.[31] The fate of the monastery would have been unthinkable in the thirteenth century when burial in a religious house was highly prestigious for the laity: these individuals must have been significant benefactors, such as Baron William de Lancaster (d.1252) who arranged to be buried near his grandfather in the church.[32]

Each effigy wears a 'great helm', which covered the head in battle and in tournaments: the knights are ready for battle, their unsheathed swords in front of them. Both figures have their legs in a walking pose, an active posture contradicted by the fact that each knight is shown recumbent, his helmet resting on a pillow depressed by its weight, his feet supported by a

Relief panel of Christ calling
St Peter *c.*1175-1200 [11]

foliate bracket.[33] There are numerous minor differences between the effigies, for instance their dimensions and the depth of the blocks, the chamfered edge as well as in details such as the eye-slits of the helmets, pillows, draperies, belts and shield shapes. This suggests that they were either carved by different sculptors at the same time or, more probably, that they were carved a few years apart. The pose seems sufficiently distinctive to indicate common authorship.

The cross-legged pose of many English effigies of knights was thought by early scholars to mean that the person depicted was a Knight Templar or a crusader.[34] Cross-legged military effigies are a distinctively English phenomenon, and generally date from the first quarter of the thirteenth century, when effigies of lay magnates first begin to appear, up to the Black Death. This dating shows that they cannot all represent crusaders, as does the almost total absence of the format in France. It seems much more likely that the idea of crossing the effigy's legs was at first a technical device intended – like the walking pose at Furness – to make the effigies visually interesting. Showing a knight in an active pose was clearly appropriate for this martial class (reinforced in the Furness effigies by their readiness for battle, expressed in their wearing of helmets and bare swords) and became a very popular fashion, explored in numerous different poses by English sculptors, and even shown two-dimensionally on memorial brasses.[35] As a consequence, English effigies of knights often exhibit a dynamic torsion which seems at odds with the fact that they usually rest their heads on pillows. In one of the Furness figures, such contradictions are accentuated by the fact that the knight is shown with his eyes shut. This was extremely unusual in English medieval effigial sculpture although it is also a feature of an ecclesiastical effigy from Little Steeping in Lincolnshire.[36]

The Little Steeping effigy again shows a

33.
One of the foliate brackets and the knight's foot appears to be a restoration. See also J.W. Hurtig, 1979, ch.III.
34.
Hurtig, 1979, pp.126ff.; Tummers, 1980, pp.117ff.
35.
See, for instance, P. J. Lankester, 'A Military Effigy in Dorchester Abbey, Oxon.', *Oxoniensia*, vol. LII, 1987, pp.145-72.
36.
Matthew Reeve of Gonville and Caius College, Cambridge, will shortly publish a new study of the retrospective effigies of Anglo-Saxon bishops at Wells Cathedral, which also have their eyes shown closed.
37.
See above, note 16.
38.
Neither the Careby nor Little Steeping figures are listed in R.E.G. Cole (ed.), *Lincolnshire Church Notes made by Gervase Holles AD 1634 to AD 1642*, vol. 1, Lincoln 1911.
39.
It now reads: 'Thomas de Red … [gyst ici. Dieu pour sa grace] et de sa alme eut merci.'
40.
S. Tarlow, 'Reformation and Transformation: what happened to Catholic things in a Protestant world?', forthcoming.
41.
N. Pevsner and J. Harris, *Lincolnshire*, Harmondsworth 1995, rev. ed. N. Antram, p.532, ascribe the effigy to Thomas of Reading, rector from 1318 to 1353 but comment that the pillow (wrongly described as placed diagonally) and the inscription in Norman French are still in the thirteenth-century tradition. The latter reads 'Thomas de Red…e de sa alme eut merci.' There are partly erased letters on the wall side too.

remarkably interesting exploration of recumbency. The figure is little known: it was only discovered in May 1917, five years after the pioneering survey of English medieval sculpture by E.S. Prior and Arthur Gardner.[37] The effigy had been broken and then turned upside down to use as a chancel step. In 1917, the Rector piously assumed that it had been hidden in the seventeenth century to avoid damage, but this seems highly improbable: seventeenth-century iconoclasts such as Dowsing would have demolished the chancel steps, so hiding the effigy upside down as a chancel step would have been pointless. It is much more likely that it had been cannibalised as a piece of convenient stone for repairs in the sixteenth century, when effigies of tonsured priests would have been held in contempt by reformers.[38] The effigy had been broken before it was reused (the lower part of the chasuble was lying loose in the church when the rest of the figure was discovered) and the inscription in Anglo-Norman French which ran round the head, right-hand side and foot of the effigy (the left-hand side rested against the chancel wall) had been damaged, something which argues against careful preservation of the figure.[39] Sarah Tarlow has shown how careful one needs to be in imputing specific motives to those who buried such objects.[40]

The effigy must originally have been fully painted. The plain bracket for a foot support is normally indicative of an early effigy, as is the plain, thin, rectangular pillow and shallow draperies. This figure is in fact extremely difficult to date, for a variety of reasons.[41] It has a number of unusual features, not least its depiction of the deceased as dead, with hands laid across the chest; this distinguishes it from the vast majority of English medieval tomb effigies. The effigy was possibly the work of a sculptor whose considerable originality was greater than his technical ability: a man perhaps without

42.
Tummers, 1980, pp.22-3, for the double tomb at Winterbourne Bassett, Wiltshire, which he dates to the late thirteenth century.

43.
The architectural surround resembles those found in the Majesty Master's work in the de Lisle Psalter, which antedates 1339. Pevsner and Harris, 1995, rev. ed. Antram, p.211, suggest this may be the monument to Sir William de Bayons, d. *c*.1327. Compare also the later Foljambe monument with its demi figures in Bakewell, Derbyshire.

44.
He also worked elsewhere in the county, producing a slightly different version of the double monument at South Stoke. There, the architectural surround is simple and uncusped, the knight and lady lie on the opposite sides of the bed, the shield resting just on his side, and the covers are carved realistically as blankets, though at the bottom of the bed, both figures have traditional animal foot supports! At Washingborough, a lady lies alone, bust length under an elaborate architectural setting with demi-angels holding her pillow. Her feet emerge from underneath the rest of the slab here carved not to represent a blanket but a large floriated cross. This type of monument, which shows only a bust-length figure, takes many different forms and was quite common in Lincolnshire, a county which displays a quite extraordinary variety of fourteenth-century tomb monuments. The Careby sculptor was also capable of producing much more conventional effigies, such as the cross-legged knight in the chancel of the same church.

45.
W.M. Ormrod and P. Lindley, *The Black Death in England*, Stamford 1995.

much experience of tomb sculpture? The inscription suggests, paradoxically, that he was illiterate: amongst the numerous clues to this are the fact that the letter S of 'Thomas' was first carved in reverse, and the u of 'eut' is upside down. This figure, like the Furness effiges, is included to show the variety and invention of English effigial sculpture: innovations in subject matter or form did not always come from London.

A similar point can be made about the curious double effigy from Careby in Lincolnshire of *c*.1325-35, carved from a single large block of stone. In the early fourteenth century double tombs were a novelty, but even for a new genre this is a strange conception.[42] The knight and his wife are shown fully dressed, their hands in prayer over their chests. However, they are sculpted apparently lying in bed together, the shield of arms resting diagonally on a fluted blanket, with their feet schematically carved at the end. Moreover, their heads, which rest on pairs of pillows, the upper one turned diagonally, are shown framed by a cusped architectural surround, given charming little 'his and hers' head stops beside their elbows.[43] The frequent ambivalence between recumbency and verticality in English Gothic tomb monuments is sometimes accentuated when the effigy is provided with a niche-like architectural surround. The sculptor of the Careby monument evidently revelled in these contradictions, dynamically accentuating the tension between horizontality and verticality.[44]

The fascinating formal, technical, intellectual and iconographic inventions in tomb monuments are counterparts to the architectural inventiveness of the period before the devastating Black Death of the mid-fourteenth century. Between a third and a half of the population of England died from the plague within two years, a population loss without parallel in recorded British history.[45] Successive visitations of the

plague may have been an important contributory factor in the growth of popularity of images of St Christopher. The belief, later satirised by Erasmus, that if you saw an image of St Christopher you would not suffer sudden death that day, made him an immensely popular saint.[46] For obvious reasons, he was adopted as the patron saint of travellers and this may well be the reason for the enormous statue of St Christopher from Norton Priory.

Norton Priory is close to a crossing point of the River Mersey between Birkenhead and Warrington.[47] In the late fourteenth century, under the energetic leadership of Prior Richard Wyche, the priory was elevated to the status of a mitred abbey and it has been suggested that St Christopher was adopted as an additional patron saint for the abbey in this period.[48] Certainly, St Christopher would have been particularly suitable because his legend related how this man, giant in stature and strength, received his name (literally Christ-bearer) because he carried the Christ Child across a deep stream, staggering under the weight of the Creator.[49] The appropriately gigantic statue was carved in three pieces of local sandstone essentially as a huge relief figure; one joint was below the knee, and another, now missing, section fitted into a gap below the saint's right arm, much of which has itself been broken but which originally held a separate, probably wooden, staff. The saint has his braies knotted at his knee as he wades through the waves, full of fish. When it was newly painted, this huge statue would have been remarkable. Quite where the statue was originally located is not clear: its existence is first recorded in 1693 and it is actually visible, in an exterior location in the outer courtyard, in a Buck print of 1727.[50] After the priory was dissolved, it may have been salvaged from within the church itself, where visitors could see the image and offer candles for the saint's protection.[51] Such salvage is generally associated with

46.
E. Pridgeon, 'St Christopher in Text and Image', unpublished MA thesis, University of Bristol, 1999.

47.
J. Patrick Greene, *Norton Priory: The Archaeology of a Medieval Religious House*, Cambridge 1989, p.3.

48.
Greene, 1989, p.67.

49.
Pridgeon, 1999, p.15ff.

50.
For Buck, see Greene, 1989, fig. 18. For the 1693 source, John Prescott's diary, I am indebted to Jon Marrow.

51.
See above p.30 for Erasmus' comments.

52.
Letters and Papers of Henry VIII, vol. 14, part 1 (1539) for the 8 March 1539 surrender by Abbot Thomas Charde. *Letters and Papers of Henry VIII*, vol. 15 (1540), pp.409 (68) and 559, for the lease to Richard Pollard.

53.
Ex info. Mr and Mrs Roper. Dr Jenny Alexander kindly drew these images to my attention.

54.
Compare the figure from the triforium level in Henry VII's chapel.

55.
F.W. Cheetham, *English Medieval Alabasters*, Oxford 1984, pp.20-30; N. Ramsay, 'Alabaster', in J. Blair and N. Ramsay (ed.), *English Medieval Industries*, London 1991, pp.29-40.

Catholic recusancy; this may have been such a case, for the head of the Christ Child was, judging from its style, most unusually restored in the seventeenth century.

As at Norton Priory, the monastic buildings at Forde Abbey in Dorset were converted into a grand house and the church totally demolished after the Dissolution.[52] In the 1970s, the present owners discovered pieces of two fourteenth-century images of female saints when digging a drainage channel.[53] The head of the figure of St Catherine still remains to be discovered but the other image has successfully been pieced together. The simplified draperies of the statue bear witness to the early influence of the alabaster industry. It probably dates from *c.*1360-90: the looped draperies of St Catherine who holds a sword and the spiked wheel of her martyrdom, seem to confirm such a dating. In spite of the damage to her attribute, it is possible to identify the second figure as St Helen, who is usually shown as a queen, a book supported on a T-shaped cross-support. Here the remains of the saint's left hand grasp the base of what seems to be a broken support: the remains of the T-shaped top are visible as a line across her cloak above her right hand and below her brooch.[54] There was, apparently, a good deal of colour visible on the figure when it was first uncovered, but this rapidly deteriorated after discovery. These niche figures of royal female saints were very probably paired, and possibly flanked the altar or window in a Lady Chapel.

Alabaster was widely used in fourteenth and fifteenth-century sculpture. It was a popular material for tomb monuments, individual statuettes and relief panels which could be grouped thematically in altarpieces or reredoses or sold singly.[55] The rather grisly devotional objects known as 'St John's head', which show the head of the Baptist on a platter, were sold in very large numbers: in 1491 one Nottingham sculp-

tor, Nicholas Hill, sued his salesman for the value of no fewer than 58 of them.[56] This was production on a semi-industrial scale and it is clear that Nottingham was a major centre of production, with the great advantage of being close to the main Midlands quarries. By this date some English sculptors, who must have headed sizeable workshops, held high civic office, an indication of their new wealth and social standing.[57] Alabaster panels and statuettes found a ready export market throughout much of Europe.[58] Many more flooded onto the market during the Edwardian Reformation: in September 1550, three or four ship-loads of images were sold at Paris, Rouen and elsewhere, much to the annoyance of one reformer. The images had not been defaced, as the Privy Council had ordered, because they could be readily sold.[59]

The *c.*1475–1500 Assumption of the Virgin is exactly the kind of panel which reformers would have found objectionable, not least because there was no scriptural authority for the subject. Here the Virgin is shown bare-headed, with her hands raised, in a mandorla held by two pairs of angels. On the bottom left at her feet is St Thomas receiving the Virgin's girdle which she sent him from Heaven to prove her body resurrection which, so the legend goes, he had doubted. Above the mandorla is the Almighty flanked by two music-making angels. The top of the block has been broken off. The panel retains a great deal of the original paint especially on the angels' wings (with their counterchanged colours) and on the mandorla itself.[60] The relief illustrates how central the Virgin had become to late-medieval devotions.

Some of the medieval alabaster panels that survived in England had been carefully buried in church floors during the Reformation: this is true, for instance, of the famous alabaster statuettes dug up under the chancel of Flawford church in 1779, and of a panel found in 1848

56.
W.H. Stevenson (ed.), *Records of the Borough of Nottingham*, vol. III, London 1885, p.19. For alabasters in a domestic setting, see Foister, 1981, pp.273-82.
57.
F.W. Cheetham, *Medieval English Alabaster Carvings in the Castle Museum, Nottingham*, Nottingham 1973, p.11.
58.
Ramsay, 1991, pp.37-9 for comments on the export trade.
59.
W. B. Turnbull (ed.), *Calendar of State Papers (Foreign) 1547-1553*, London 1861, p.237.
60.
Cheetham, 1984, pp.199, 202 and 203 for similar representations. The Nottingham panel was purchased in 1988.

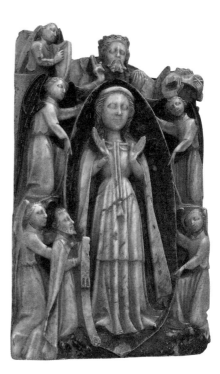

Relief panel of the Assumption of the Virgin *c.*1475-1500 [20]

under the chancel floor of St Mary's church in Nottingham.[61] It may also be true of the Resurrection panel which was itself bought in Nottingham in 1925; judging by the soldiers' armour this dates from the early fifteenth century. Christ is shown stepping out of the tomb (depicted as a medieval tomb-chest) onto one of the sleeping soldiers, all of whom are shown in contemporary armour. The motives of those who hid such objects may be difficult to recover but there can be no doubt that some, at least, like Roger Martin at Long Melford, were hoping for the restoration of Roman Catholic religion.

The Resurrected Christ is also represented by the mutilated torso of Christ from Winchester Cathedral. This image has been terribly damaged by iconoclasts, who sawed up other statues from the same reredos to reuse them as building stone.[62] The emaciated torso of Christ with his prominent abdomen and ribs, and the superbly rhythmical folds of the draperies of the loin cloth, hint at the original quality of the scupture. Traces can still be seen of the stumps which supported the crossed staff and penant. The alabaster panel exhibited nearby indicates something of its original appearance.

The particular attention paid by iconoclasts to images of Christ is true even of the Christ Child. His head was probably smashed off the Norton Priory St Christopher and was certainly broken off the image of the Winchester Cathedral Virgin and Child, carved, in all probability, by an accomplished sculptor from the Low Countries.[63] In the later fifteenth century, Netherlandish art dominated Britain and the finest sculptors working in England were from the Low Countries, prior to the arrival of Italian sculptors such as Pietro Torrigiano in the early sixteenth century. The Virgin and Child, a sculpted counterpart to the panel paintings of Hugo van der Goes, seems

61.
Cheetham, 1973, pp.18-25 and 36; see also, for example, G.F. Wilmot, 'A Discovery at York', *Museums Journal*, vol. 57, 1957, pp.35-6. See also the alabaster found in 1774 in the roof of a house at Coddenham, Suffolk: Cooper, 2001, p.219.

62.
Each of the other surviving figures had the head and shoulders sawn off at an angle of 45 degrees and a similar treatment was given to the base, so that the flat backs of the figures could be reused as double corners on one of the new walls constructed at Winchester when, after the dissolution of the Cathedral Priory, the Close was divided into areas for canons' houses and gardens. See P. Lindley, 'Figure-Sculpture at Winchester in the Fifteenth Century: A New Chronology', in D. Williams (ed.), *England in the Fifteenth Century*, Woodbridge 1987, pp.153-66; J. Hardacre, *Winchester Cathedral Triforium Gallery: Catalogue*, Winchester 1989, pp.38-9.

63.
P. Lindley, 'The Great Screen of Winchester Cathedral. Part I', *Burlington Magazine*, vol. 131, 1989, pp.604-14; Lindley, 'The "Great Screen" of Winchester Cathedral. Part II: Style and Date', *Burlington Magazine*, vol. 135, 1993, pp.796-807.

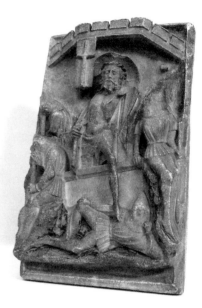

Relief panel of the Resurrection of Christ *c.*1400-30 [21]

64.
If the statues had survived Bishop Ponet's episcopate, Queen Mary and King Philip would have seen them on 25 July 1554 as they celebrated their nuptials in the cathedral before the high altar; the statues would certainly not have survived Bishop Horne, who had earned a reputation when Dean of Durham as an extreme Protestant 'who might never abyde any auncient monument' and who had obliterated the great reredos of New College, Oxford, in 1567.

65.
See P. Lindley, 'The Great Screen and its context', in M. Henig and P. Lindley (ed.), *Alban and St Albans*, Leeds 2001, pp.256-70.

66.
G.W.F. Hegel, *The Philosophy of History*, London 1956, p.409. For the sixteenth-century commentator Hieronymous Emser, see Aston, 1993, p. 226: 'it would save money and improve devotion to have really bad images'. James Calfhill, writing in 1564, claimed that 'the livelier the counterfeit is, the greater error is engendered' (Aston, 1988, p.408).

67.
T. Serel, *Historical Notes on the Church of Saint Cuthbert, in Wells*, Wells 1875. See British Library MS Egerton 2747, no. 1, for a scale painting of the whole reredos. See also P. Tudor-Craig, *Richard III*, National Portrait Gallery 1973, p.3.

to have been one of the central images from the huge programme of the *c.*1470-90 Great Screen at Winchester Cathedral. Here the heads were knocked off the figures, and the bodies of most of the statues were sawn into three for reuse as building stone, their flat backs turned outwards.[64]

The heightened naturalism of which Netherlandish sculptors were capable is demonstrated by the superb clean-shaven male head of one of the life-sized figures from the same programme. Portraiture as a genre had been rediscovered in the fourteenth century, and this head shows that the finest Netherlandish sculptors were capable of the same physiognomic accuracy as contemporary painters. Some of the statues from this programme were equipped with headgear of other materials; this seems likely in the case of the Virgin who perhaps wore a triple tiara, of which only the lower crown was stone, the upper two of metalwork. Both these images come from the Great Screen, the huge reredos of the High Altar of Winchester Cathedral, and were part of a densely crowded, glittering and colourful witness to the celebration of Mass, exalting the status of the priest who celebrated this central sacrament of the Late Middle Ages.[65] It may be the case that the realism of the finest late-fifteenth-century statues actually contributed to their superstitious abuse and thus, paradoxically, to their own destruction. Hegel once declared that the coarsest and poorest works of art served the purposes of medieval religion better than the finest products; in this, though he did not know it, he echoed sixteenth-century commentators.[66]

Roughly contemporary with the two fragments from the Winchester Cathedral Great screen is a figure from a Tree of Jesse reredos in the south transept of St Cuthbert's, Wells. In 1848, oak panelling was removed during a restoration campaign and the remains of the reredos uncovered behind it.[67] The iconoclasts

Statue of the Resurrected Christ
*c.*1380-90 [17]

had smashed the figures to pieces, put most of the fragments back into the niches and then plastered the whole composition over after hacking the recumbent figure of Jesse himself in deep relief almost back to the wall. What now survives is little more than an outline of the original figure. The Tree of Jesse is a composition in which the ancestry of Christ and Old Testament figures who prophesied the Incarnation were linked: medieval Christians interpreted the Old Testament as prefiguring the New. This figure, in two rather crudely painted fragments, which was reunited with the help of Hohn Hardacre, had already been rejoined in the nineteenth century as the crude mortar repair indicates. The prophet points to a scroll which bears a quotation from Deuteronomy 4 vs.32. Uniquely, the contract for this composition, which covered much of the south transept wall at St Cuthbert's, survives together with some of the (very damaged) sculpture from the reredos; this gives the name of the sculptor as John Stowell and the date of the work as 1470-2.[68]

By extraordinary good fortune, the oak figure of Jesse which came from a similar composition in the priory church of St Mary at Abergavenny, survives. This is without doubt one of the finest pieces of fifteenth-century wood sculpture remaining in England or Wales. The initial dismantling of the Tree of Jesse took place in the sixteenth century: when a Royalist soldier visited the church, he noted: 'At the east end of the north yle church lyes a large statue for Jesse, and a branch did spring from him, and on the boughs divers statues, but spoyld.'[69]

The figure of Jesse lies recumbent, his head resting on a pillow supported by a single angel. The hat appears to have had an ornamental stone fixed into the front. Jesse's missing right hand was a separate piece, dowelled on, but otherwise the whole figure is carved out of a single piece of what must have been a massive

68.
Stone, 1972, p. 227, is certainly wrong in separating this sculpture from the Tree of Jesse reredos. The measurements of the figures confirm that they come from the reredos. I hope to be able to resume the work begun in the late 1980s next year. Matthew Reeve has offered me invaluable help in identifying the text borne by the prophet.
69.
C.E. Long (ed.), *Diary of the Marches of the Royal Army, During the Great Civil War*, London 1859, pp.233-38.

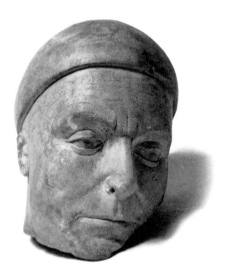

Head from a life-sized statue
*c.*1475-90 [16]

oak: the tool marks from an adze and curved chisel are evident (as are the knots in the wood, especially on Jesse's left thigh). Of course all the visible surfaces would have been painted, and traces of colour – such as the gold of the angel's hair and green on the bough which springs from his chest – are still evident. This extraordinary figure has, like the St Christopher from Norton Priory and the Forde Abbey saints, escaped the notice of previous scholars of British medieval sculpture.[70]

Another remarkable survival is a statue of St George, from one of the interior buttresses in Eton College Chapel's ante-chapel.[71] The statue is shown in an 1816 engraving, but has attracted very little interest because it and its companion statue of St Edmund are so high up.[72] A number of interesting features of the sculpture emerged from its study for this exhibition. Although the top of the helmet and visor had been abraded with a wire brush, the rest of the surface seems to be in excellent condition and I could find no evidence that it had ever been painted.[73] The fact is of interest because this sophisticated statue was carved by the master sculptor of Henry VII's Chapel, Westminster, and the sculpture of that chapel seems never to have been painted either.[74] The sculptor was evidently interested in the appearance of the sculpture from the floor of the chapel: the bevor (chin-protection) has been omitted so that one can see the saint's mouth, but the most extraordinary evidence that the sculptor has tried to take the spectator's viewpoint into account is the fact that the tip of the sword's blade is carved on the left arm, and only 'reads' as part of the sword when it is seen from below. This exhibition is the first time the sculpture will have been closely visible since the first or second decade of the sixteenth century.

Henry VII's Chapel at Westminster Abbey houses the tomb monuments of Margaret Beaufort (Henry VII's mother) and of Henry VII

70.
The eminent sculpture conservator John Larson first alerted me to the existence of this sculpture. Its significance was for the first time noticed by Andrew Graham-Dixon in *A History of British Art*, London 1996, pl.7.

71.
Lindley, 1995, pp.156-69.

72.
Dr Paul Williamson kindly drew my attention to the statue.

73.
The left hand grasps something which has been broken off – perhaps part of the lance, the rest of which lies on the dragon's wings, with the point through its neck.

74.
The wooden statue of St Derfel mentioned above, of a man in armour, may well have resembled this figure, perhaps with a representation of a devil – a symbol of the saint's ability to liberate souls from Hell – as a substitute for the dragon.

75.
A.P. Darr, 'The Sculptures of Torrigiano: the Westminster Abbey Tombs', *Connoisseur*, no. 200, 1979, pp.177-84.

76. See the essay co-authored with C. Galvin, 'The Tomb of Dr John Yonge in the Public Record Office', in Lindley, 1995, pp.188-206.

77.
A death mask seems to have been used on the funeral effigy of Edward III at Westminster Abbey; this dates from 1377.

78.
This is argued in Lindley, 1995, pp.47-72.

himself and his wife, Queen Elizabeth of York. Both these commissions were won by the Florentine sculptor Pietro Torrigiano, who profoundly changed the traditions of medieval tomb-sculpture in England and Wales.[75] His effigy of Dr Yonge, displayed here, comes from a wall-monument dated to 1516; in this monument Torrigiano imported Florentine Renaissance traditions into England.[76] In many ways the effigy displayed here was equally revolutionary. It is made of terracotta and was fired in three separate hollow sections; the head was a cast from a death mask. This was the first time that a death mask had been used in a tomb effigy in England.[77] The effigy retains a good deal of its original polychromy, which helped to hide any constructional defects (such as were revealed during Carol Galvin's conservation of the monument in 1990). In conception, the figure strangely resembles the priest's effigy from Little Steeping, but this apparent similarity is an example of pseudo-morphology: there is no actual connection between the pieces. Revealingly, neither had any long-term impact on later developments, and Torrigiano's royal effigies show the deceased with their eyes open. Dr Yonge's executors may have been prepared to allow the sculptor some leeway for this effigy of a prominent, Italian-trained lawyer, which was simply not permissible for effigies of royalty.[78] Where Torrigiano did make significant innovations in his English tombs, however, was in the design of the tomb-chests, where he introduced new materials such as white marble and Italian Renaissance forms. Torrigiano's terracotta portrait bust of Henry VII, now in the Victoria and Albert Museum in London, also employed a death mask and was one of the first sculpted portrait busts in England: Italian sculptors introduced a new genre of secular sculpture into England, just as they also introduced freestanding statues of classical subjects. Both were to have great significance after the Reformation.

The break from Rome and the onslaught on religious imagery discouraged other Italian sculptors from coming to England, but there was still a demand for the fashionable decorative repertoire of Renaissance forms. This can be clearly seen in the latest work on display, a work which provides a bridge to the Tate's permanent collections. This is the alabaster tomb with three effigies from Charwelton in Northamptonshire (like the Careby and Little Steeping effigies, it has been especially conserved for this exhibition). Neither of the last two nor the Furness effigies probably had tomb-chests. However, from the thirteenth century it was increasingly common for sculpted effigies to be raised up on a tomb chest. The Charwelton tomb is a fine example of a freestanding alabaster monument, perhaps the first choice of format and material for the wealthy in late-medieval England.

The tomb of Sir Thomas Andrew and his two wives, Katherine Cave (d.1555) and Mary Heneage, is one of a series of Midland alabaster monuments attributed to the English sculptor Richard Parker, who is first recorded working in Burton-upon-Trent in 1532.[79] His only extant documented work is the magnificent tomb to Thomas Manners, first Earl of Rutland (d.1543), and his wife Eleanor Paston.[80] Jon Bayliss has shown that Parker's career was 'adversely affected by the religious and political changes of the mid-sixteenth century', because the Dissolution of the Monasteries made earlier tombs available for cheap reuse, undercutting the costs of a new monument.[81] During conservation of the Charwelton tomb monument for this exhibition it was discovered that Parker himself had taken advantage of the Dissolution to cannibalise an earlier alabaster monument, the inscription being hidden when the alabaster blocks were reused in the base mouldings of the Andrew tomb.[82]

79.
J. Bayliss, 'Richard Parker "The Alablasterman"', *Church Monuments*, vol. v, 1990, pp.39-56.
80.
V. Manners, 'The Rutland Monuments in Bottesford Church', *Art Journal*, 1903, pp.269-74. In the executors' accounts for the earl's tomb, Parker was paid £20 'for makyng a tombe of alabastre for my Lorde and Ladye, to be sett at Botelford, accordyng to the effect of an indenture'. Other works, such as the fine monument of Sir John Blount (d.1531) at Kinlet in Shropshire have been attributed to Parker on the basis of comparisons with the Bottesford tomb. There, the core was erected by separate craftsmen and this also seems to have been the case at Charwelton.
81.
Bayliss, 1990, p.51.
82.
It should be stressed, though, that there is copious evidence from before the Dissolution for the casual reuse of earlier monuments: it was the huge numbers of monuments made available in so short a time that was unprecedented. See e.g. V. Harding, 'Burial Choice and Burial Location in Later Medieval London', in S. Bassett (ed.), *Death in Towns: Urban Responses to the Dying and the Dead, 100-1600*, Leicester 1992, pp.119-135 (129).
83.
Stylistically, the monument is close to that of Sir Thomas Bromley (d.1555) and his second wife Isabel Lyster at Wroxeter in Shropshire, which also features a pair of angels holding a coat of arms at one end.

An inscription in raised black letters runs round the Andrew tomb: 'Sub ista tumba jacet domina Katerina Andrewes: prima uxoris Thome Andrewes militis un'a filiar' et heredum Edwardi Cave Armig'i quequidem Katerina obiit decimo octavo die Augusti anno millesimo quingentesimo quinquagesimo quinto, of howse solle God have mercy. Amen.'[83] The inscription, which mixes Latin and English, thus dates the tomb after 1555 and before the death of Thomas Andrew in 1564. The seven sons and three daughters of Thomas Andrew are gathered round their father and mother at the east end of the Charwelton monument (the end of the right-hand daughter's draperies are carved on a separate piece of alabaster, perhaps a replacement for a piece broken in mid-sixteenth century transit). The corner pilasters of this monument are a 'signature' feature of Parker's work but are almost the sole evidence of Renaissance influence on the tomb.

The Charwelton monument functions as a 'metatomb' in this exhibition, summing up, in many ways, medieval traditions, but inevitably also posing questions about the future and about the impact of the Reformation. Its form as a freestanding monument, the choice of alabaster, its employment of painted colours, the emphasis on children and heraldry and its black letter inscription, all align this tomb with its late-medieval predecessors. The open-eyed effigies, with their hands together in prayer, are examples of a type popular since the fourteenth century. These are generalised representations of the deceased rather than accurate portraits such as Torrigiano provided for Dr Yonge's executors: the two lady effigies, for instance, are almost identical. The angels at the west end bearing the Andrew arms and motto are, similarly, the descendants of those found on thousands of earlier tomb-chests. It is not clear

whether anything can be safely read into the final phrase of the inscription about the beliefs of Thomas Andrew or his wives. The English invocation of God's mercy might testify to a genuinely Catholic belief in Purgatory, but without even knowing the exact date at which the monument was commissioned – for it may belong to Mary's reign or Queen Elizabeth's – it is hard to say whether it did or not.[84]

However, the monument also raises the key issues of what cannot be displayed in this exhibition. One major absence is the architectural context, with which sculpture often had extremely sophisticated and complex relationships. All the sculpture exhibited in the Duveen Galleries belongs in an ecclesiastical environment, and many of the images came quite specifically from pieces of architectural furniture. This is obviously the case with the Much Wenlock lavabo panel, as well as the early fifteenth-century York Minster vault boss which Richard Deacon was keen to feature here; it is also true of many of the other sculptures.[85]

All the tomb sculptures shown here belong in religious houses or parish church interiors, where most substantial tomb monuments were located. The Charwelton monument comes from a location which would, in the Middle Ages, have indicated the presence nearby of a chantry altar, endowed with prayers for the deceased. This highlights the fact that one thing which would have been of the utmost importance to all medieval patrons has been totally lost with the changes of the mid-sixteenth century. The abolition of Purgatory under Edward VI destroyed the whole intercessory apparatus, the soul-masses, the candles and prayers, designed to help the soul through the pains of Purgatory to Paradise. It was not just the physical inheritance of traditional religion in England and Wales which the national, Protestant church effaced.

84.
See Duffy, 1992, pp.504-23, for cautions on the use of will evidence. D Hickman, 'Reforming Remembrance: Funerary Commemoration and Religious Change in Nottinghamshire 1500-1640', *Transactions of the Thoroton Society*, vol. 103, 1999, pp.109-24.
85.
Truly freestanding sculpture hardly existed in medieval England and Wales for most sculptures were housed in architectural niches, backed onto a wall, or belonged in an architectural ensemble: for some of the sculptures, such as the York Minster and St Mary's figures, their original architectural context is still a matter of intense debate.

[10] Effigy of an ecclesiastic c.1260-70
From St Andrew's Church, Little Steeping, Lincolnshire
Limestone
h 29 cm, w 194 cm, d 49 cm
St Andrew's Church, Little Steeping
(pages 6-7, 59)

[11] Relief panel of Christ calling St Peter c.1175-1200
Lavabo fragment from Much Wenlock Priory, Shropshire
Silurian Wenlock Limestone
h 77 cm, w 65 cm, d 13 cm
English Heritage
(pages 43, 66-7)

[12] Recumbent figure of Jesse, late 15th century
From St Mary's Priory Church, Abergavenny, Wales
Oak
h 89 cm, w 293 cm, d 58 cm
St Mary's Priory Church, Abergavenny
(pages 70-1, cover)

[13] John Stowell
Fragments from a Tree of Jesse c.1470-2
From St Cuthbert's Church, Wells, Somerset
Limestone
h 115 cm, w 34 cm, d 18 cm
St Cuthbert's Church, Wells
(page 61)

[14] Statue of St George c.1510
From Eton College Ante-Chapel
Limestone
h 155 cm, w 54 cm, d 44 cm
The Provost and Fellows of Eton College
(pages 14, 23)

[15] Statue of the Madonna and Child c.1475-90
From Winchester Cathedral
Limestone
h 48 cm, w 34 cm, d 20 cm
Dean and Chapter of Winchester
(page 64)

[16] Head from a life-sized statue c.1475-90
From Winchester Cathedral
Limestone
h 23 cm, w 16.4 cm, d 24 cm
Dean and Chapter of Winchester
(page 50)

[17] Statue of the Resurrected Christ c.1380-90
From Winchester Cathedral
Limestone
h 47 cm, w 28.2 cm, d 13.8 cm
Dean and Chapter of Winchester
(pages 49, 65)

[18] Pietro Torrigiano
Effigy of Dr Yonge 1516
From the Rolls Chapel at Chancery Lane, London
Terracotta
h 36 cm, w 186.5 cm, d 57 cm
The Crown Estate & King's College London
(pages 6-7, 59)

[19] Two fragments of a Crucifix c.1130
From All Hallows Church, South Cerney, Gloucestershire
Wood, covered in gesso and paint
head: h 14.5 cm, foot: h 12 cm
The British Museum, London
(page 38)

[20] Relief panel of the Assumption of the Virgin c.1475-1500
Original location unknown
Alabaster
h 39.5 cm, w 25.5 cm, d 5 cm
Nottingham City Museum & Galleries: The Castle Museum & Art Gallery
(page 47)

[21] Relief panel of the Resurrection of Christ c.1400-30
Original location unknown
Alabaster
h 46 cm, w 30 cm, d 6 cm
Nottingham City Museum & Galleries: The Castle Museum & Art Gallery
(pages 48, 65)

[22] Attributed to Richard Parker
Tomb of Sir Thomas Andrew and his two wives c.1555-64
From Holy Trinity Church, Charwelton, Northamptonshire
Alabaster
h 126 cm, w 230 cm, d 258 cm
Holy Trinity Church, Charwelton
(pages 5, 6-7)

[23] Statue of St Helen c.1360-90
From Forde Abbey, Dorset
Limestone
h 105 cm, w 28 cm, d 19 cm
Forde Abbey, Dorset
(page 61)

foreground, Statue of
**St Christopher carrying the
infant Christ** *c.*1375-1400 [8]

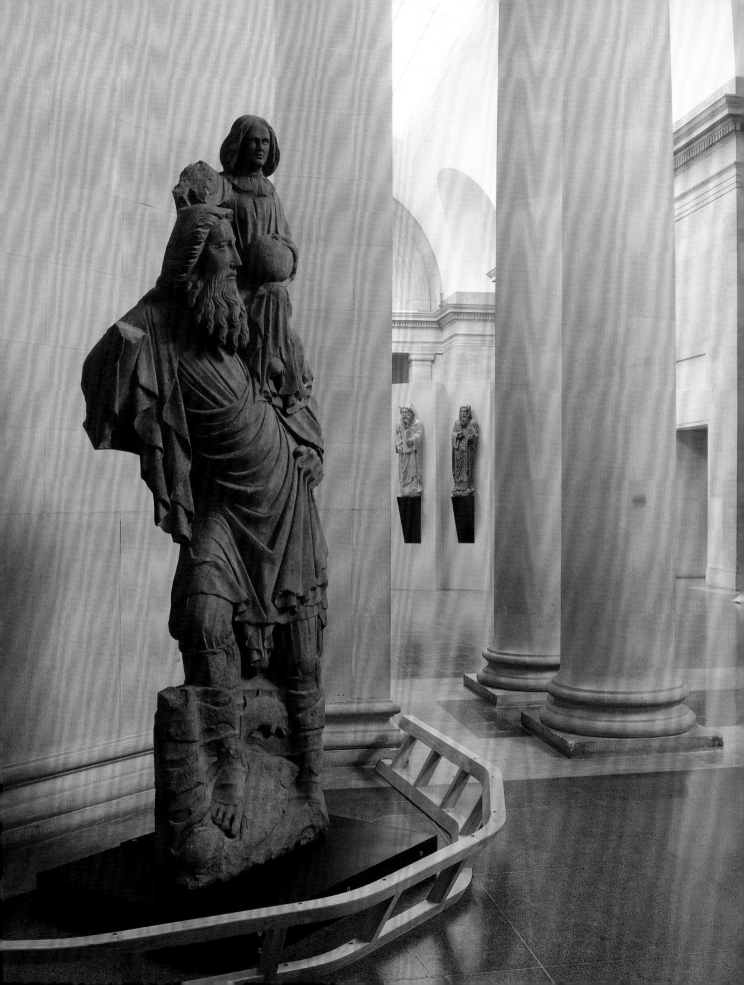

Effigies of knights in full armour
*c.*1250-75 [6,7]

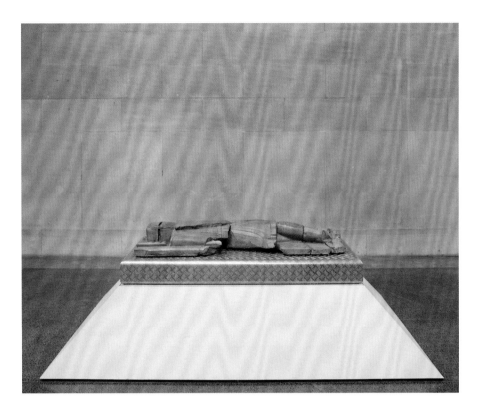

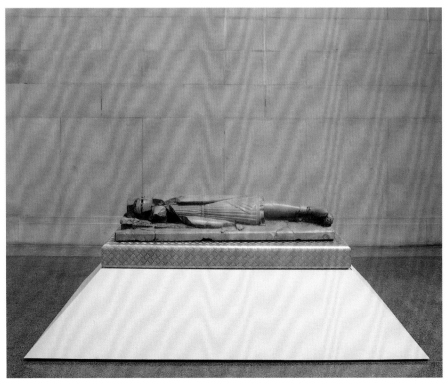

left:
Pietro Torrigiano
Effigy of Dr Yonge 1516 [18]
right:
Effigy of an ecclesiastic
*c.*1260-70 [10]

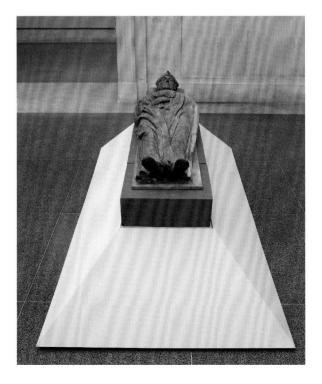

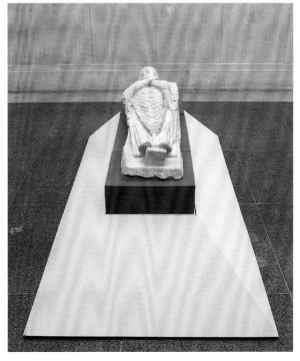

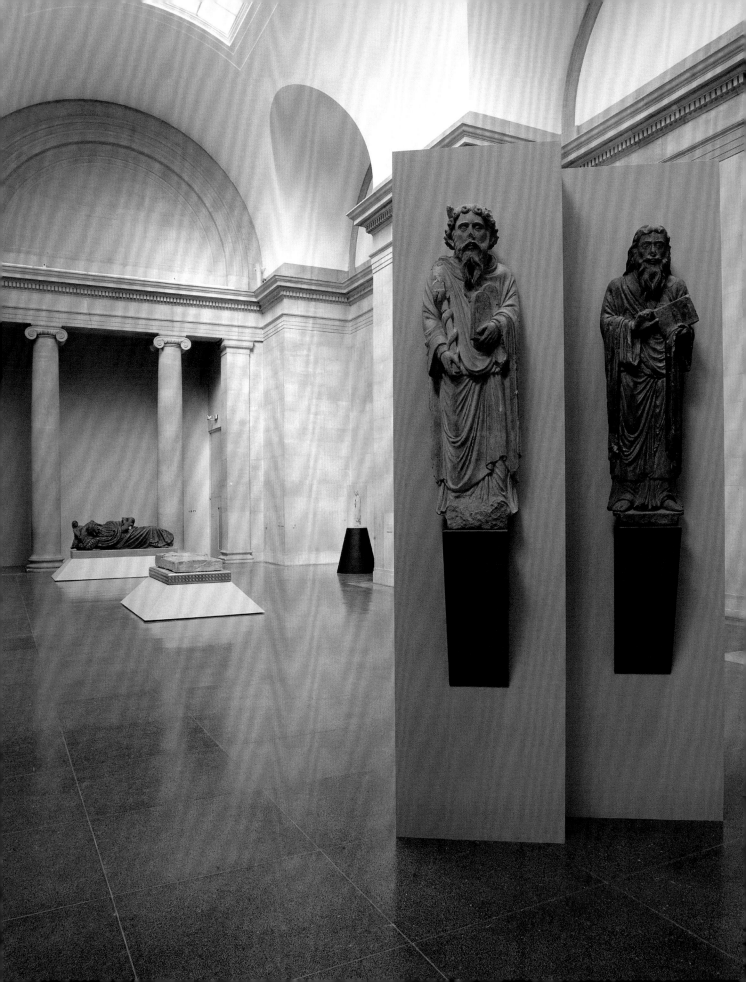

left:
foreground, left, Moses c.1200 [1]
foreground, right, An Apostle (?)
*c.*1200 [2]
below:
left, Statue of St Helen
*c.*1360-90 [23]
right, John Stowell
Prophet from a Tree of Jesse
*c.*1470-2 [13]

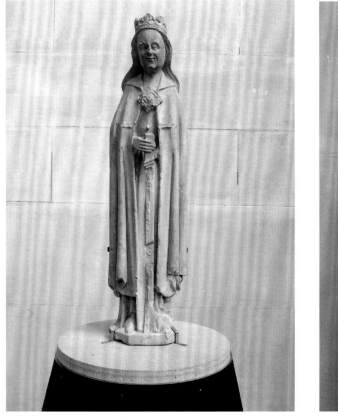

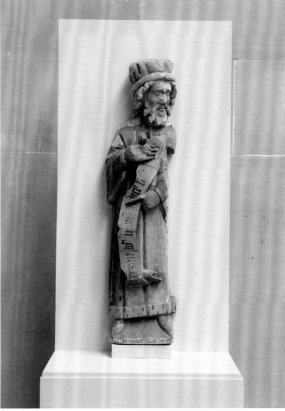

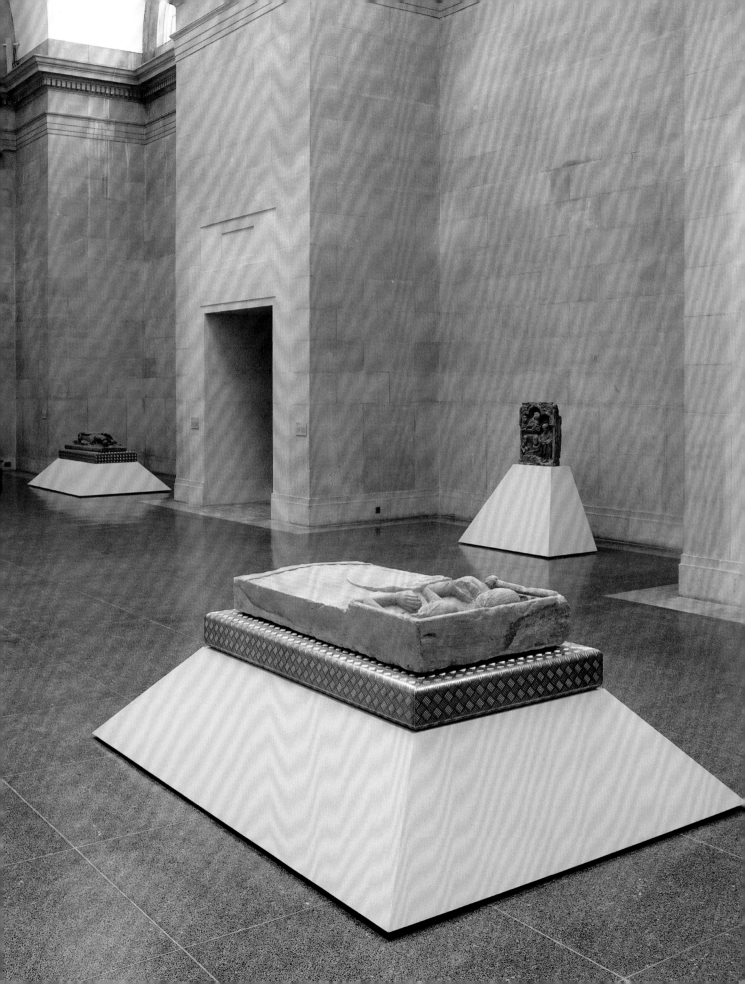

left and below:
foreground, Double effigy of
Armoured Knight and Lady
*c.*1325-35 [9]

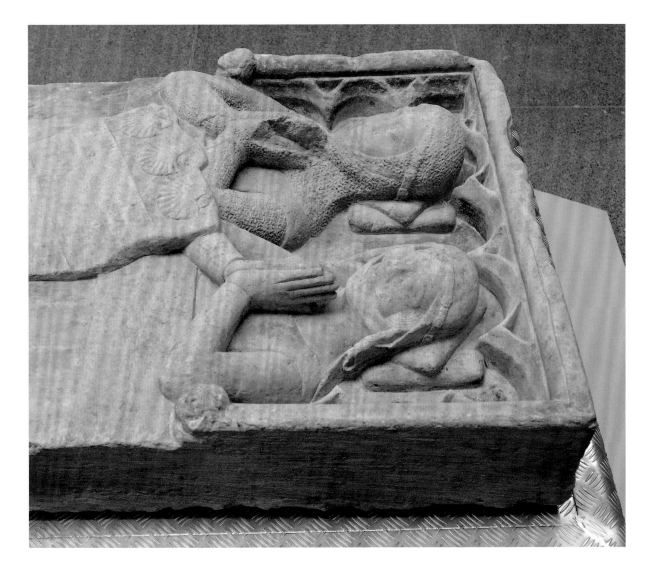

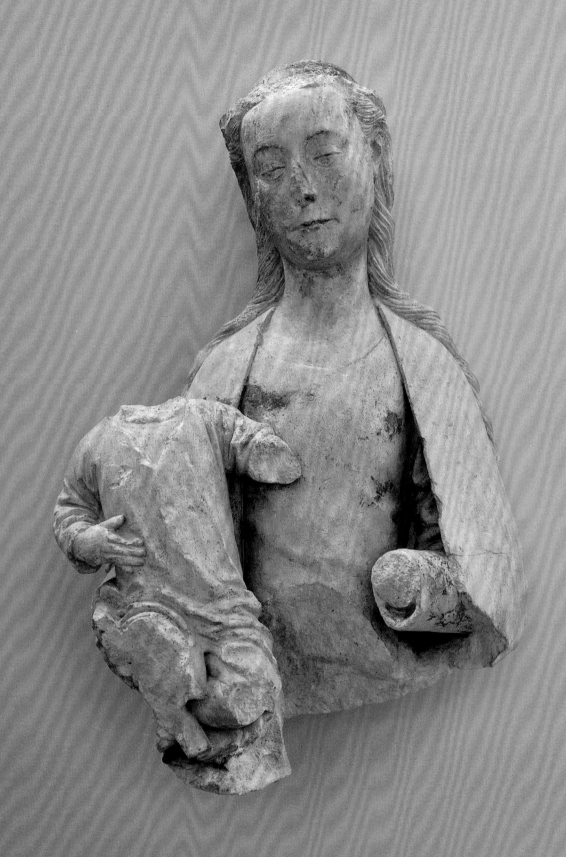

left:
Statue of the Madonna and Child
*c.*1475-90 [15]
below:
left, Relief panel of the
Resurrection of Christ *c.*1400-30 [21]
right, Statue of the Resurrected
Christ *c.*1380-90 [17]

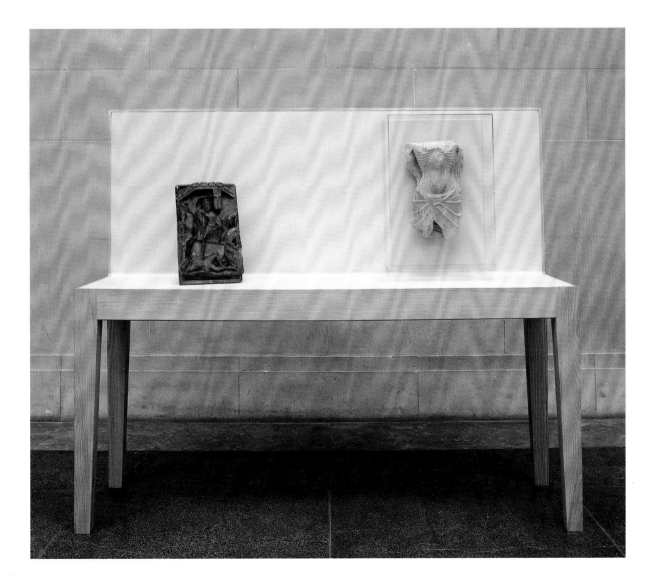

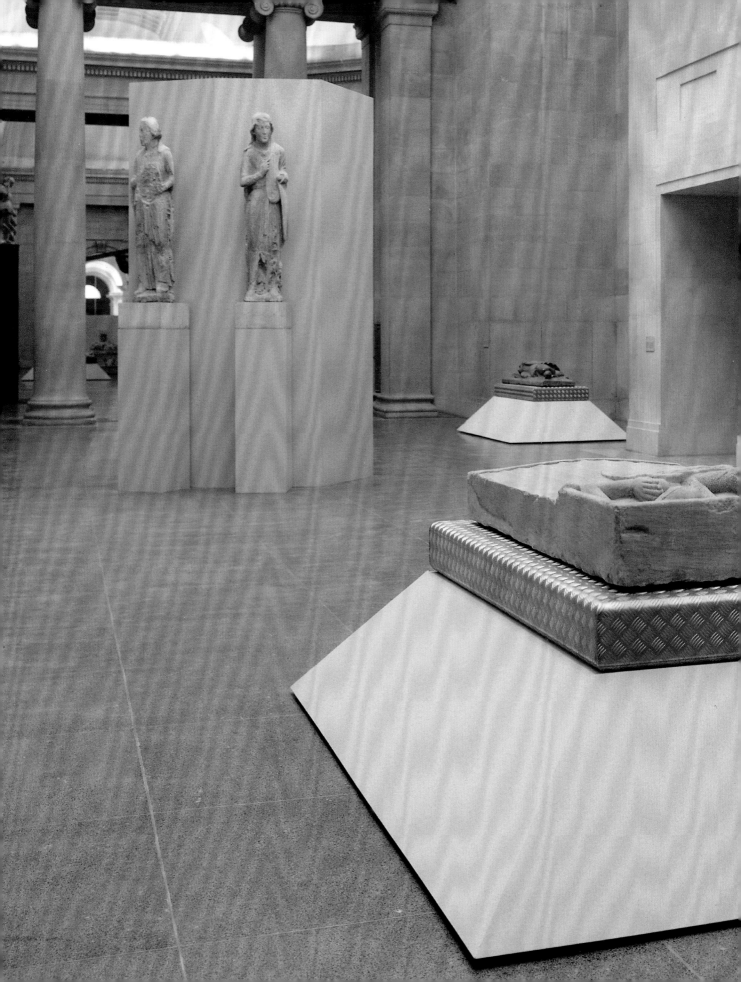

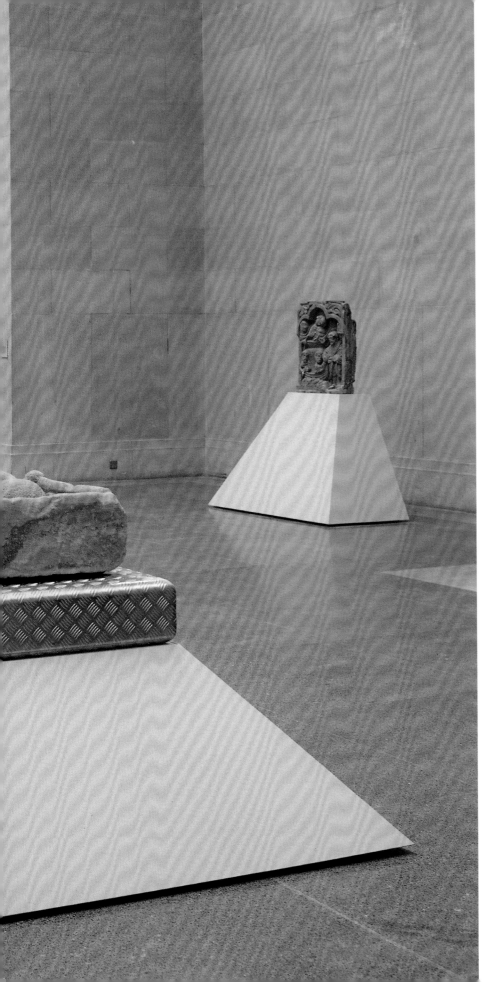

foreground, centre, Double effigy
of Armoured Knight and Lady
c.1325-35 [9]
foreground, right, Relief panel of
Christ calling St Peter
c.1175-1200 [11]
middleground, left, An Apostle (?)
late 12th century [3]
middleground, right, Queen of
Sheba (?) [4] late 12th century

left, An Apostle (?)
late 12th century [3]
right, Queen of Sheba (?)
late 12th century [4]
overleaf:
Recumbent figure of Jesse
late 15th century [12]

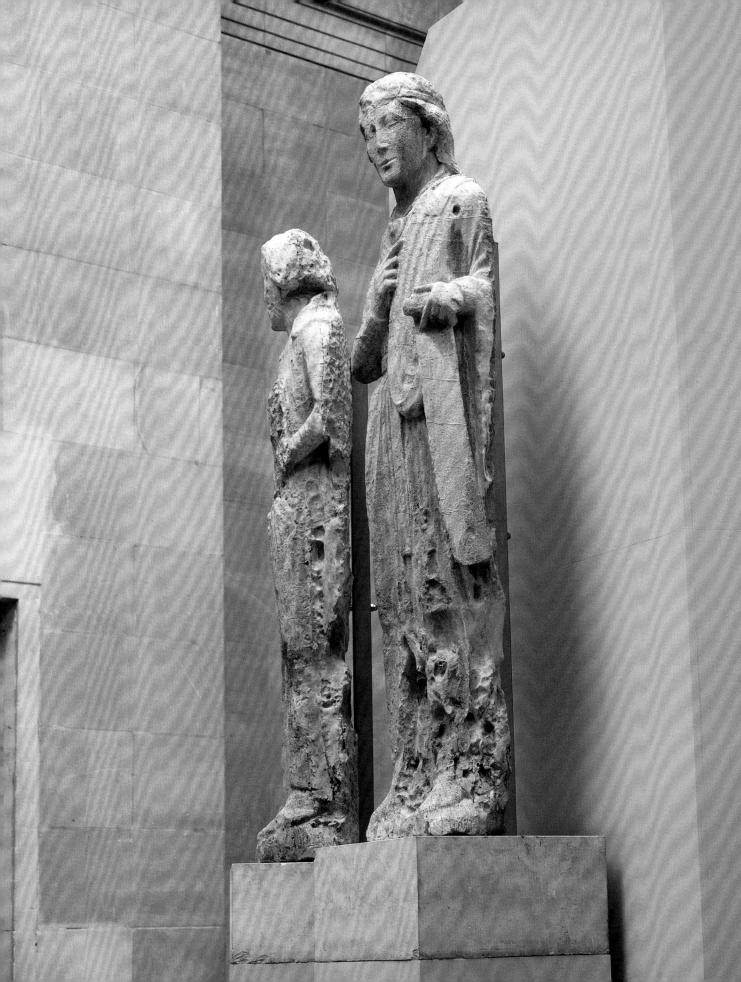

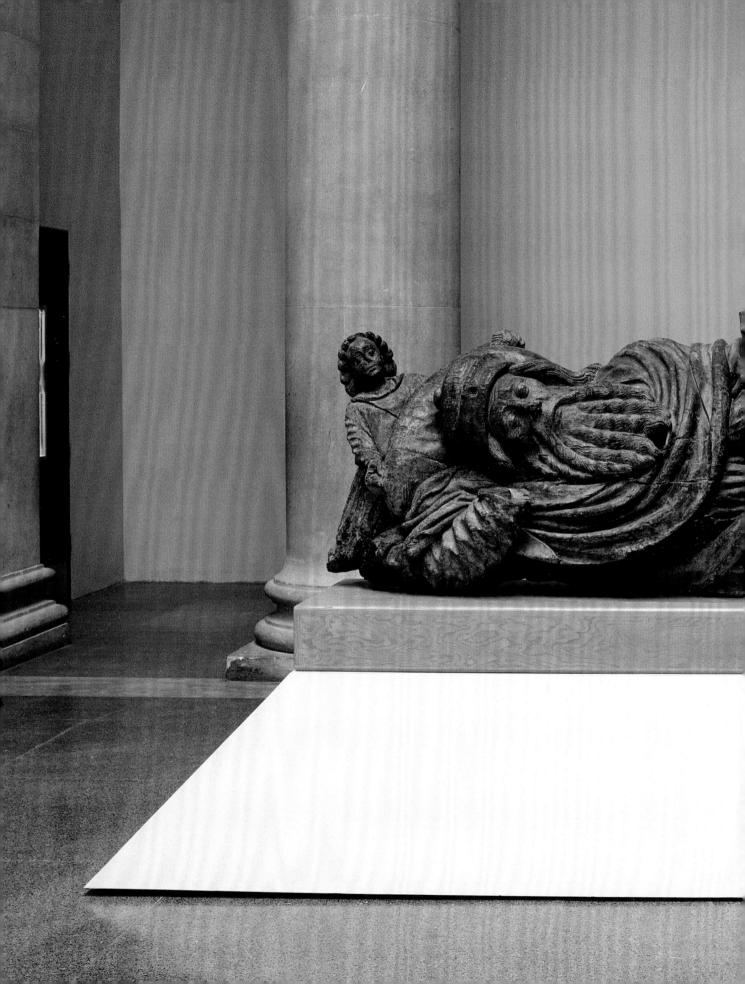

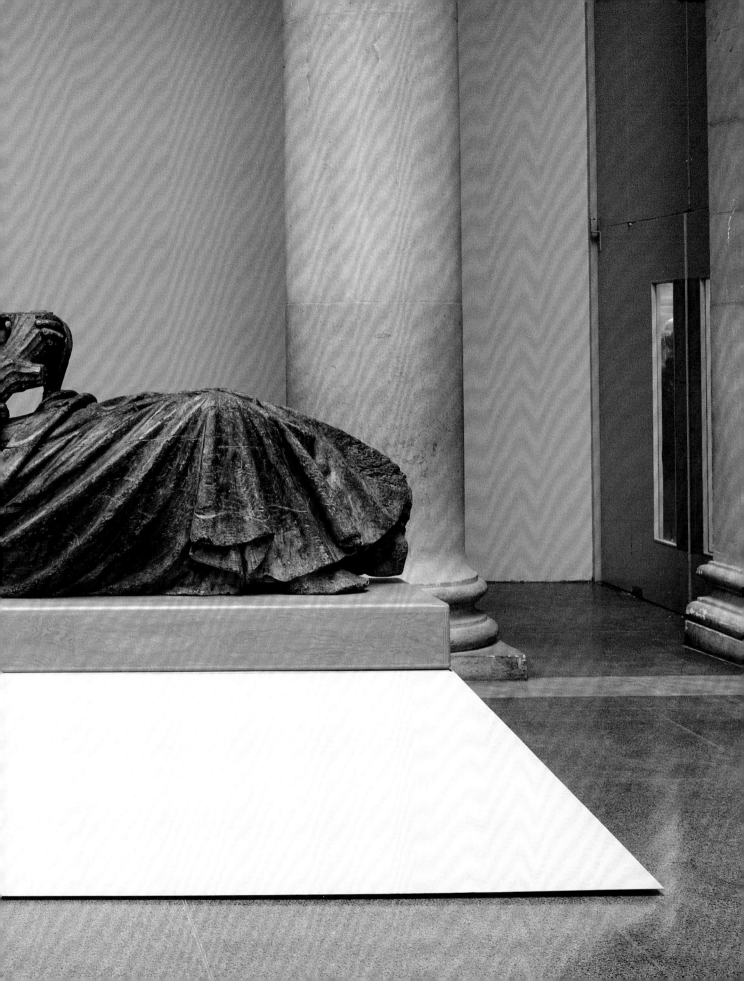

ACKNOWLEDGEMENTS

Many people have been involved in the realisation of this project. In addition to the comments made in the Foreword, we would like to acknowledge the contributions of a number of individuals and institutions who have helped make this exhibition possible.

Our debt to the lenders of works is profound and we would like to join with Stephen Deuchar in thanking: The British Museum, The Crown Estate & King's College London, The Dean and Chapters of Bath & Wells, Lincoln, Monmouthshire, Peterborough, Winchester and York, English Heritage, Eton College, Forde Abbey, National Museums & Galleries on Merseyside, Nottingham City Museum & Galleries and the Yorkshire Museum. The willingness and enthusiasm of owners to participate in such an ambitious undertaking has been very gratifying.

Within Tate we are grateful to the following members of staff for their important contributions: Joanna Banham, Anne Beckwith-Smith, Gillian Buttimer, Lizzie Carey-Thomas, Celia Clear, Simeon Corless, Ann Coxon, Sandra Deighton, Andrew Dunkley, Jimmy Dyer, Jim France, Richard Guest, Gemma Haley, Mikei Hall, Mark Heathcote, Tim Holton, Richard Humphreys, Sarah Hyde, Tessa Jackson, Carolyn Kerr, Mike Kruger, Marcus Leith, Ben Luke, Peter MacDonald, Fran Matheson, Jehannine Mauduech, Jennifer McCormack, Rachel Meredith, Jacqueline Michell, Dr Martin Myrone, Stephen Newsome, Andrea Nixon, Pat O'Connor, Sharon Page, Daniel Pyatt, Mary Richards, Katherine Rose, Andy Shiel, Floyd Varey, Stella Wilcox, Glen Williams and Simon Wilson.

One of the joys of preparing this exhibition has been the opportunity to work closely with specialist conservators. In particular we would like to thank Laura Davies, Jackie Heuman and Derek Pullen from the Tate conservation team for their invaluable advice and support throughout the project. Additional assistance has been provided by a number of independent conservators. Among them we would especially like to thank David Bennett, Heather Bird, Brendan Catney, Mike Eastham, Carol Galvin, Heather & Seamus Hanna, John Larson, Matthew Nation, Jim Spriggs, Keith Taylor and Leesa Vere-Stevens.

Our gratitude also goes to the many others who have helped realise this exhibition including: Eric Anderson, Andrew Argyrakis, Nick Baker, Michael Bartosch, Revd Brian Bennett, Andrew Bond, Catriona Boulton, Jonathan Carey, Gary Chapman, John Cherry, Peter Collier, James Cook, Dr Louisa Connor, Phil Crew, Mr & Mrs Creasey, Jan Croysdale, Niels Dietrich, Anne Fahy, Revd Peter Farrell, Very Revd Raymond Furnell, Philip Gee, Louise Hampson, Nick Hanika, John Hardacre, Elizabeth Hartley, Penny Hatfield, Mrs Hinchcliffe, Sonia Jones, John Juson, Adrian Last, Carolyn Losely, Professor Lucas, Dr Sara Lunt, Brigadier Peter Lydden, Clare Manchester, Jon Marrow, Marshalls Mono Ltd, Mrs Matthewman, Mr Mills, Guy Morey, Dr Andrew Morrison, Karen Perkins, Matthew Perry, Revd Michael Petitt, Dr David Pound, Fiona Raley, Mr & Mrs Roper, Kirstie Sessford, Bill Slade, Mike Smith, Revd Philip Sourbut, Sovati Smith, Joel Taylor, Very Revd Michael Till, Julian Treuherz, Clare Van Loenen, Venerable Roderick J Wells, Dr Paul Williamson, Oliver Wilton and Revd Jeremy Winston.

Richard Deacon, Phillip Lindley and Clarrie Wallis

Photographic Credits:
 p.10, Associated Press, AP
 pp.9, 12 top and below, 38, © The British Museum
 p.28, Cambridge University Library
 p.11, Richard Deacon
 pp.49,50, The Dean and Chapter of Winchester / John Crook
 p.27, English Heritage. NMR
 p.43, © English Heritage Photo Library
 p.24, The Royal Collection © 2001, Her Majesty Queen Elizabeth
 cover, pp.5, 6-7, 8, 14 left and right, 17, 18-19, 20, 21, 23, 47, 48, 57, 58 top and bottom, 59 left and right, 60, 61 left and right, 62, 63, 64, 65, 66-7, 69, 70-1, Tate Photography
 pp.40, 41, Courtesy of The Yorkshire Museum / Andrew Dunkley and Marcus Leith